EFFECTS AND TRICKS

EFFECTS AND TRICKS

PAINTING

WATER

AND REFLECTIONS

JOSÉ M. PARRAMÓN

Director: José M. Parramón Vilasaló
Texts: José M. Parramón y Gabriel Martín
Editing, layout and design: Lema Publications, S.L.
Cover: Lema Publications, S.L.
Editorial manager: José M. Parramón Homs
Editor: Eva M.ª Durán
Translation: Lauren Hermele
Original title: *Agua y Reflejos*
Coordination: Eduardo Hernández

Photography and photosetting: Novasis, S.A.

First edition: october 2000
© José M. Parramón Vilasaló
© Exclusive Publishing rights: Lema Publications, S.L.
Published and distributed by Lema Publications, S.L.
Gran Via de les Corts Catalanes, 8-10, 1.º 5.ª A
08902 L'Hospitalet de Llobregat (Barcelona)

ISBN: 84-8463-016-1
Printed in Spain

Table of contents

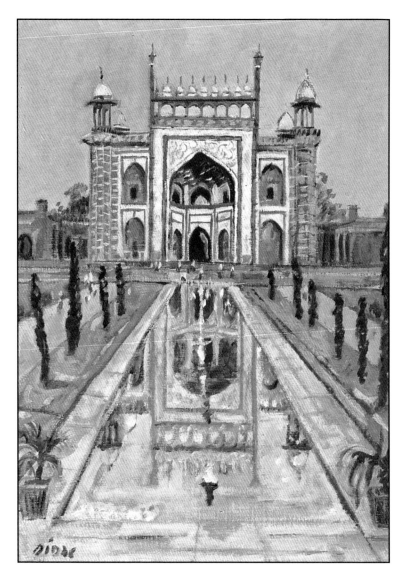

Painting water is not just a pleasant and evocative motif, it also raises a series of pictorial questions that no amateur painter should ignore. The solidity of the land and its structures have a fascinating contrast with the continual movement and activity of the water. Water's unique ability to be both a transparent substance and a mirror at the same time is what fascinates artists; and for this reason, lakes, rivers, and oceans have been considered some of the most popular landscape motifs. Even with such popularity, it is surprising to see to what extent this interest, has been a relatively new theme in occidental art –a theme that has only begun to develop in the last few centuries. It might have been the landscape artists from Holland in the 18th century who began to take the ocean's chromatic and luminous variations seriously. The 18th century in Holland witnessed how the love for water in landscape painting influenced English watercolorists in the 18th and 19th century. Among the most distinguished watercolorists were Thomas Girtin, Samual Palmer, John Sell Cotman, and William Turner. They observed and painted the rivers' movements, torrents, and the local scenic waterfalls. Later on, particularly influenced by Turner, the French impressionists, with Claude Monet in mind, chose water as the protagonist of their work. Both the seascape and the views of the rivers with bridges, which reflected out onto the calm waters, acquired a special importance in their work. Monet could possibly be the artist who knew the most about painting ponds. The impressionists divided the elements of light in order to produce an impression that moved away from the perception of water as a valued, naturalist, and photographic reality, and moved towards the view of water as an explosion of color, which deserved vigorous brushstrokes. Years later, the divisionists including Derain, Seurat, Signac, and Regoyos, reintroduced this theme of water into their work and included it within the majority of their landscapes. The greatest water "portraitists" of the 21st century, aside from Monet, could be the American artist, Winslow Homer and the Spanish artist Joaquín Sorolla. Homer was very interested in the strong effects that the river's current produced and the violent swell of the ocean. Sorolla almost always used the Mediterranean ocean as the background for his paintings, which, usually bathed with generous light, provoked surprising chromatic vibrations on the surface.

1

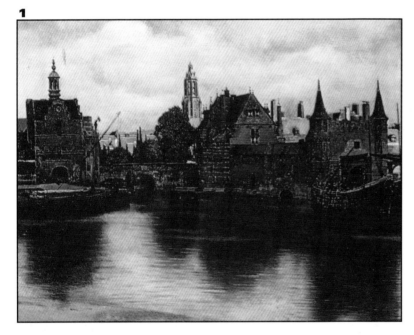

Fig. 1. **A view of Delft** *by Vermeer (Mauritshuis, La Haya).* **The Dutch Baroque artists were the first to introduce clearly and evidently the effect of water on landscape painting.**

Fig. 2. **A cloudy pond** *by John Sell Cotman (National Gallery of Scotland).* **The English watercolorists regularly included rivers and ponds in their landscapes. They were interested in the changing aspect that the water had in relation to the sky, as well as the reflections that were produced upon its surface.**

2

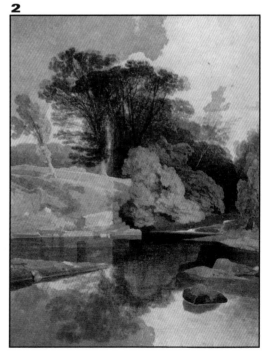

However, painting the ocean is not easy, it is necessary to know at least a few tricks in order to be able to achieve the crystal-clear effect, the texture, the reflections, and to capture the constantly changing colors. In this book, reproduced works appear in which water is the main protagonist. These works are as different in their technique as in their style, which is demostrated in the detailed explanation. There are many different ways to paint water, so it is difficult to say which is the best, but in order to capture the various effects, the artist should know some basic principles. It is important that the site has an good orientation so that serious difficulties in dealing with the water can be avoided. It is also important that the amateur, who practices and follows the techniques and advice given throughout the exercises, discovers that, in general, the best answer to any question is perseverance, and that the actual masters of painting are the rivers, the lakes, and the swells that crash over the rocks.

Gabriel Martín Roig
Art critic

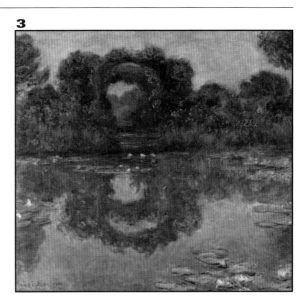

Fig. 3. **The Arch of Flowers** *by* **Claude Monet (Phoenix Art Museum). Monet was one of the greatest painters of ponds. No one but Monet knew how to portray the mirror-like reflection of the vegetation on the water's calm surface.**

Fig. 4. **A cove in San Vicent** *by Joaquín Sorolla (Sorollo Museum, Madrid). The ocean and the Mediterranean light give this impressive Spanish artist an interesting setting in which he can depict the ocean's brilliant and luminous colors.**

Fig. 5. **Below the waterfalls** *by Winslow Homer (Brooklyn Museum). The rough water in the background triggers this dramatic scene, where a canoe attempts to fight against the rough current below the waterfall.**

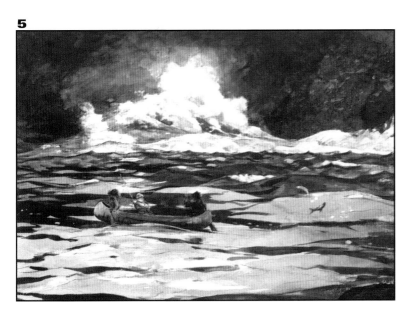

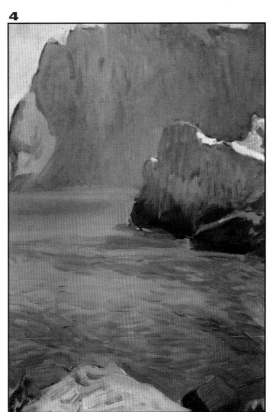

The water's chromatics

Like in no other genre, when you paint large stretches of water, the harmonization of color is an extremely relevant factor. If you try for one moment to remember the visual sensations that you feel when standing in front of the ocean, you will realize that color powerfully dominates over the profiles, the volume and the general forms. The ocean is hardly definable, it is just color. Nevertheless, the changing aspect of the water becomes evident as we study color.

In the first place, in order to understand the chromatic variations that water experiences, we should forget the prejudice that the ocean is always blue. There is not just one color that can define water, even though you may believe the contrary. The color of the ocean's water or the color of a lake, reflect the color of the sky, which means that a luminous sky will correspond to a bright blue ocean. If the sky is covered with clouds, the ocean will be grayer. On the other hand, during sunrise, the ocean's surface will be dominantly orange, yellow and purple. The color of the water covers an entire range of colors- it varies from the deepest darkest Prussian blue, to the most brilliant and shocking reds, and it can even reflect the nuances of Ultramar, green, and turquoise.

The only advice I can give you in respect to painting the color of water, is that you should try to interpret with total veracity the color that you are seeing –without worrying about regulating or harmonizing– and you should practice regularly, and always in a natural setting. Claude Monet knew that consistency was a very important value in regard to understanding the effects of the ocean, and wrote: "Every day I understand more about this cunning devil. I am going crazy because I understand that in order to paint the ocean with exactness, you need to examine it every day, at different hours, but from the same spot". The painter should know how to observe, and discern the tones and then be able to bring this to their canvas.

Figs. 1-7. While looking at these figures you should ask yourself the questions: what color is the water? How can you see that the water itself does not have just one color? Its color depends as much on the atmospheric conditions as on the surrounding landscape. Try to analyze each of the illustrations and attempt to understand why the water has taken on a certain color in each of the described circumstances.

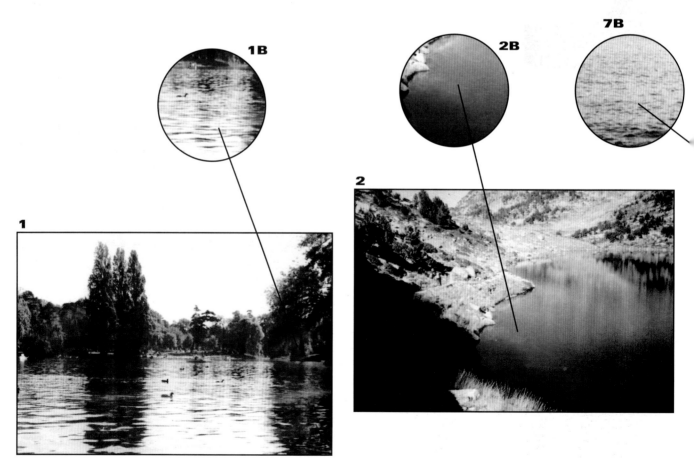

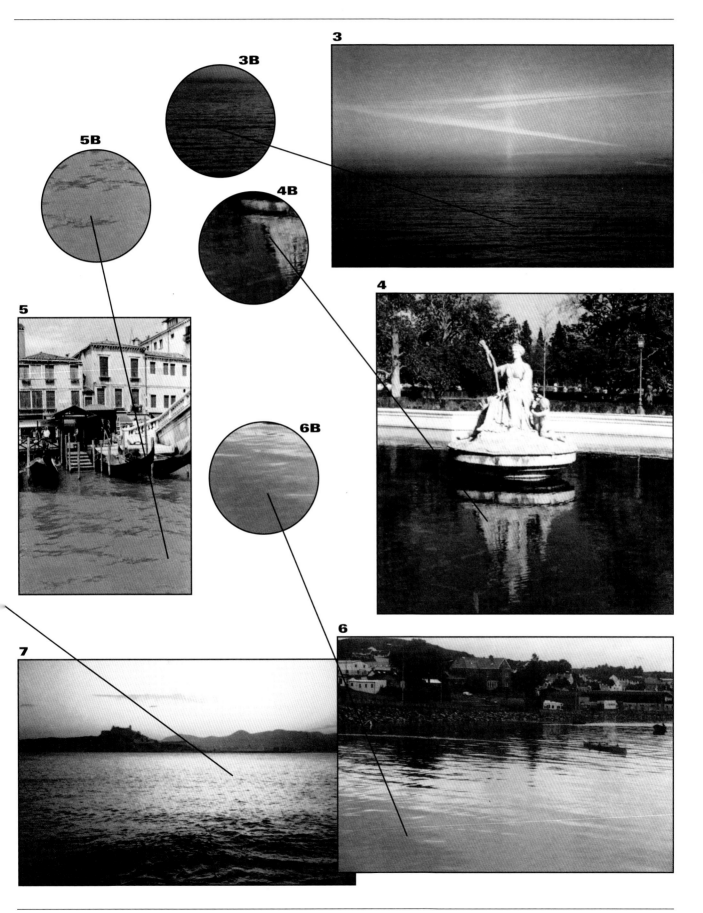

The reflections

The effect that reflections produce on the water's surface has always stirred admiration among amateur painters. Despite the apparent difficulty of the execution, with a few small pieces of advice, painting reflections can actually be quite easy. However it demands careful observation on your behalf when it is comes time to paint.

Water always acts like a mirror, but it is when the water is calmest that the reflections can flower across its entire surface. The calm pond water always displays a painting: the exquisite reflection of the objects that rest above the surface. A form that lies near the shore will have an inverted reflection on the surface. In order to paint a reflected form, all we have to do is to make the vertical edges go downwards; these will determine the height of the form. By joining them we can obtain the upper horizontal edges, and with this, the process is finished. If we raise the reflected element above the water's surface, the reflected image will also move in the opposite direction and at an equal distance on the surface of the reflection. We can summarize all this with the following sen-tence: "The distance between one point and the surfaces" reflection will be the same that exists between this surface and the reflected point". The reflections on the water are clearer and more colorful on a sunny day, while on a cloudy day, they are usually dull and diffused. The reflection will always correspond to the intensity and position of the light source. With this, I am also referring to sunset, when the reflections of vessels tend to be darker and retain a silhouetted form for a longer time.

1

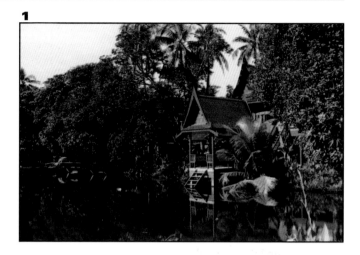

There is another added difficulty when you begin to paint reflections- the agitation of the water's surface. It is rare that the water's surface is still and motionless, usually, the reflected images are distorted and deformed. The true effect of water can be achieved through the occasional distortion from a breeze or current. In order to work with smooth reflections, use the most horizontal strokes possible; but if you

2

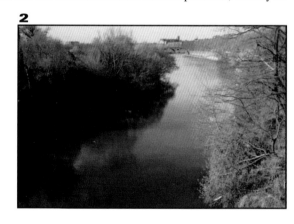

3

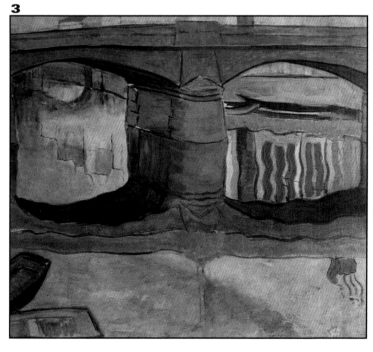

Fig. 1. This image of a lake with a rose garden close to Bangkok (Thailand) has a crystal-clear reflection. The calm water looks like a mirror and it reflects with extraordinary clarity all the vegetation and the houses along the shore.

Fig. 2. Here is another example of a crystal-clear reflection, although this time it is set on the Garona river, which passes through the French city of Toulouse. The reflections in this case appear clearer than the actual vegetation, giving the water's surface a chromatic variety that is very interesting to the artist's eye.

Fig. 3. Reflections in Ondárroa by Julián de Tellaeche (private collection, Bilbao). The ocean's water, never stays still, and for this reason, in the best case scenario, the reflections will provide a smooth and undulating line.

are working in the open air and you are rushed, mark the space that they occupy and then elaborate the images later with vertical lines. The real construction of a calm and elongated reflection can be accomplished by using horizontal lines, but it is often difficult to draw the descending shadows with gently enough by using the horizontal stroke; in these cases it is better to use the vertical stroke. When there are many vibrations, the reflections begin to tremble and you have to paint them with audacious descending undulatory strokes.

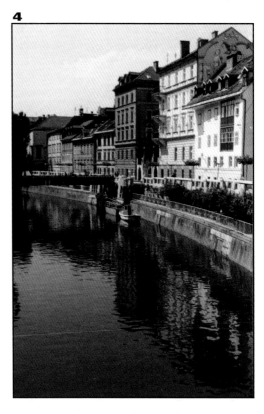

Fig. 4. When the waters move the reflections distort and create sections that are more imprecise with undulating and wavering profiles. In this illustration we see an example of the Liubliancia River's path in Liubliana, the capital of Slovenia.

Fig. 5. Fishermen *by Paul Henry (National Gallery of Ireland). When the sun is lower than the shadow or reflection that projects the figures, the figures appear darker and more elongated.*

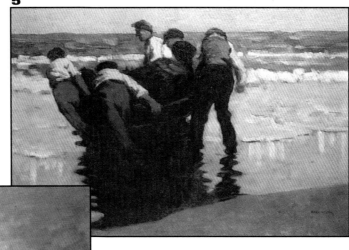

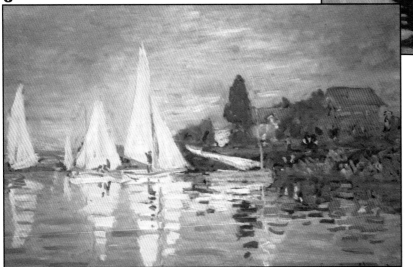

Fig. 6. Race in Argenteuil *by Claude Monet (Museum Orsay, Paris). This is one of Monet's works in which the reflective effect is emphasized. He did not treat the reflections suavely; they just look like a series of horizontal short marks that are projected downwards. Remember that reflections are brighter and more colorful on sunny days.*

The ocean

For as long as we can remember, man has been attracted by the ocean's immensity, its fierce movement, its colors, and its chameleon-like characteristics. A classic genre of painting has been derived from the ocean weather which offers a large amount of artistic possibilities.

When an amateur artist paints the ocean, the main problem could be the lack of a visible structure; it can be complicated to simulate depth and distance if there are no reference points (like boats, islands or cliffs) nearby or near the horizon. Also, the ocean water is always changing, and constantly moving, lacking any precise form. When the ocean is painted from a distance it is hard to perceive its nuances. It appears like a mass of uniform color and illustrates a pleasant gradated tone. Usually when the water is close by a pleasant undulating texture can be seen on the surface of the waves, and in the sunlight's reflections.

A general norm is that the color of the ocean appears clearer closer to the horizon, and appears darker towards the beach. Along the coastline, the colors of the

1

water become darker and more intense; they form an amazing symphony of tones and celestial nuances of ochre and turquoise. When painting the ocean close to the coast it is advisable to leave a few slits in the paper to suggest the luminous rays that usually fall onto the water's surface. The brightest spots should always remain white, this way you can apply gray tonalities to represent the nuances of the model. Calm water does not present any special problems, but in the ocean, the waves can sometimes be difficult because their form changes every second, and they have to be observed with great detail. If you look you will see that there is a definite logic to the movements: the waves ripple and crash the same way over and over again. Try to use your brushstrokes to describe these movements and to prevent the composition from appearing static. The white foam will have to be painted almost from memory, and by making registers around the dark limits of the rocks and the ocean; if you are using watercolors, you can do this with liquid rubber. The most common techniques used to paint foam with oil paint is with paste (which can be used with a paintbrush or a spatula), or you can use the dry paintbrush technique to create this gra-

2

Fig. 1. Water's variable characteristics and constant movement are a few of the factors that have attracted so many artists to include it in their compositions. This has been derived from a pictorial subject matter known as "marine".

Fig. 2. The Bas-Butin coast by George Seurat (Fine Arts Museum, Tournai). The ocean view from far away should be represented with a gradated tone using intense and clear colors close to the coast. These almost melt into the blue of the sky near the horizon.

Fig. 3. The cloud, by Émile-René Ménard (private collection, Paris). The chromaticism that the sky displays directly affects the color displayed by the ocean. The mirror quality of the ocean always matches the color of the sky.

3

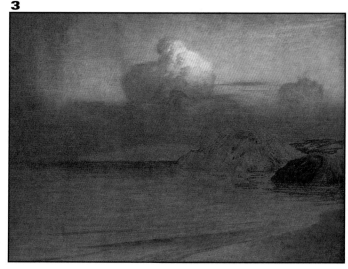

nulated very characteristic effect. The surface of the ocean is continuously moving and always being altered, which is why, in general, the ocean does not produce reflections. You may have to wait for the boat to stabilize in order to appreciate the reflections of the vessels, or, you may have to wait for the water to be calm during sunset to see the silhouettes of the moored vessels on the water right next to the coast.

4

Fig. 5. If we want mobility and strength we should go where the ocean violently breaks against the coastal region. This snapshot which was taken in Sitges, a spot along the Catalan coast, is an interesting model for practicing the painting of waves and foam.

5

Fig. 4. Storm on the coast of Belle-Ile by Claude Monet (Museum Orsay, Paris). The strong waves that break against the rocks are indisputably the protagonist of this work. The direction of the dry paintbrush and the white paste help to create the foam.

Fig. 6. Along the rocky cliffs of the Costa Brava you can find coves like this one that present an interesting game between transparency and turquoise colors. To paint seascapes it is not always necessary to paint the wide-open sea, nooks such as this,The Cala Forada (the cove full of holes) in Palamós, are also quite interesting.

6

7

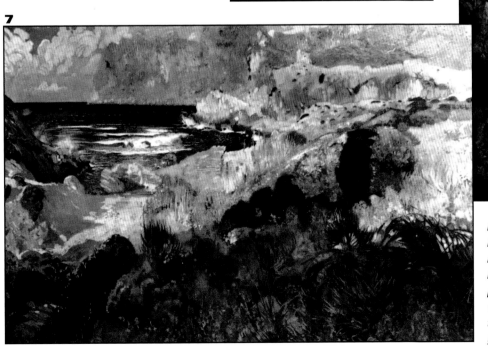

Fig. 7. Sant Vicenç cove by Joaquim Mir (Montserrat Museum). The coastal regions often provide an interesting motif. In this example, the chromatic protagonist are the rocky formations, while the ocean functions like a counterpoint, like a mere secondary protagonist.

Lakes and ponds

The mirror effect on the surface of the water is most evident when the water is at a standstill or when it is gently flowing and calm- this state is usually found in lakes or ponds. The stillness of the water can be communicated by means of conventional brushstrokes; the horizontal strokes create the surface and the strokes should not appear neither very marked nor very dull, they should be blended so that the color transitions are very subtle. The painting of a lake should be treated as delicately as the reflections that may be held on its surface; if there is the slightest movement in the water, the horizontal lines will be diffused and broken, while the vertical lines will remain the determinant. The oblique lines will also be determinants in proportion to their inclination.

When painting the calm waters of a pond or a lake it is necessary to carefully observe the surfaces; disturbance lines. You have to try as hard as possible to make the curves of these lines as accurate as possible. With smooth reflections and sufficient gradate, it is almost certain that a pleasant effect will be achieved. Rocks seen through the water, always appear distorted because they are refracted, therefore, if the general structure of the rock shows straight parallel lines over the water, you can be sure that there are actually

curves down below. In these cases it will be difficult to know what is what, but where the reflection is the darkest, it will be easier to see through the water and vice-versa. The more vertically you look over the water, the better you will see the objects; the more obliquely you look, that is, the lower your eye is in relation to the surface, the better you will see the reflections. Sunny days are not the best days to try to paint the bottom of a lake or a pond, because the surface reflections obstruct the ability to see the bottom.

1

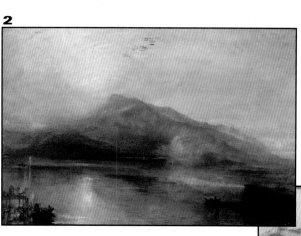

2

3

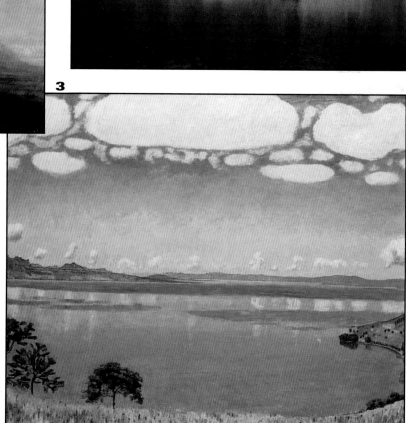

Fig. 1. Lakes, opposite from the ocean, are a pool of calm water, opportune for reflections. They tend to be surrounded by a very different landscape than the marine landscape, that is, usually by abundant vegetation and precipitious hills.

Fig. 2. **Brientz lake** *by William Turner (private collection). This lake, painted in watercolor was treated with a plain wash. The artist looked for simplicity and not for the effects of the reflections to reproduce the slightly altered crystal-clear surface of the lake.*

Fig. 3. **The Gineva Lake seen from Chexbres** *by Ferdinand Hodler (Kunstmuseum, Basel). He used turquoise colors, to emulate the nearby vegetation, and the remote parts of the painting show better chromatic mimicry of the sky, they also reflect part of the clouds.*

4

Objects that are submerged in the water do not show their real colors. In general, the trunks and rocks that are submerged present a dominant chromatic that tints the bottom the same color. In other words, it is as if you were working with a color filter which was superimposed on the bottom of the pond. Many times the water acts like a filter and unifies the colors of the elements that cover the bottom of the lake.

7

5

Fig. 4. Ponds are romantic places that have always drawn the artist's attention. They are usually considered to be more interesting if they are accompanied by vegetation and statues, which create a more bucolic image.

Fig. 5. Aranjuez Garden by Santiago Rusiñol (Modern Art Museum, Barcelona). The peace and tranquility that the pond's still water creates has drawn many symbolist artists who look for their spiritual values there.

Fig. 6. Nymphs by Claude Monet (National Museum of Western Art, Tokyo). Monet painted reflections like no one else could at the pond in his garden in Giverny. Notice how he dealt with the vegetation by using horizontal strokes, and how the colorful reflections are represented with vertical brushstrokes that anticipate the abstraction of the painting.

Fig. 7. The rocks that can be seen through the water appear to be oversized because of the magnifying effect of the water. They do not show their real colors, they actually appear to be filtered by a patina that standardizes the colors. In this case, the bottom of this pond should display ochre and greenish colors.

6

The flow of water: rivers and waterfalls

The water from rivers and waterfalls is usually in constant motion. The light sparkles and the shadows appear and disappear; this complicates the artist's work. It is difficult to capture the transitory effects without loosing the sensation of movement and fluidity. Many different rivers can be differentiated by their color and the roughness of their water. In respect to color, the Irish rivers are a reddish color because of the presence of iron in their banks; the Asian rivers are yellow because of the quantity of mud that they transport; and the rivers in the jungle are usually perceived as a green color because of the influence of the nearby vegetation. All rivers, whether big or small, coincide in one characteristic; they like to be slightly inclined towards one

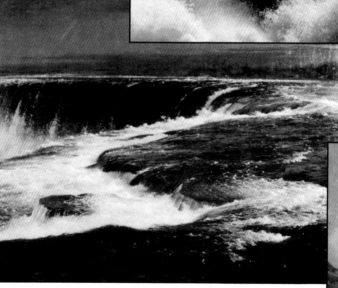

Fig. 1. The cascades present an unmistakable white color and have the texture of a thousand drops that spray and precipitate. This texture is an attractive element for the amateur artist.

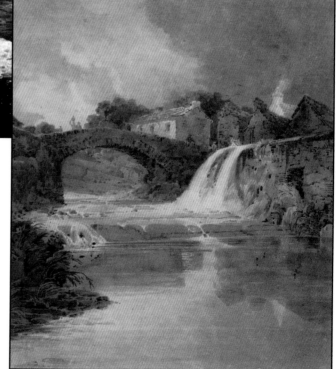

Fig. 2. If you look thoroughly at a river's rapids, you will see that the foam that the rough water generates is not just composed of the color white. Behind this curtain of rough water the shadows of the rocks and the innumerable shades of ochre and green are hidden; which are no more than the light reflected from the nearby vegetation.

Fig. 3. Niagara Falls by Federick Church (Corcoran Gallery of Art, Washington). Man has always been drawn to nature's magnificence, which can be seen in paintings such as this, that try to capture the spectacular side of natural phenomena.

Fig. 4. Hawes by Thomas Girtin (Birmingham Museum and Art Gallery). The water's spray adds new attractive visuals and a certain sensation of mobility to scenes that have pools of calm water like this one. Cascades were a highly utilized landscape resource during Romanticism.

side; they do not like their path to be deepest right in the middle. This means that they usually have one sunny bank and one shady bank. In order to paint the river's path, I probably do not have to tell you that it is extremely important to correctly draw the curves of the banks. These lines are not subtle if anything, they need to be more exact than any other lines found in nature. If you make an error while drawing the curvature of a trunk or a branch, this error may pass by unnoticed, but if you make the same error when drawing the curves of a stream or a beach, an careful observer may notice. In a limpid mountain stream, the most wonderful and complicated effect may be seen when the shadows and the reflections of the rocks mix with the real view of the rocks through the water. The movement of a choppy stream can be transmitted through varied and creative brushstrokes. But painting becomes complicated when you have to paint the 'saint of water', that is, the waterfall. When painting a waterfall, do not try to freeze it in just one moment; take a few strokes with moderation in order to produce an impression of mo-

5

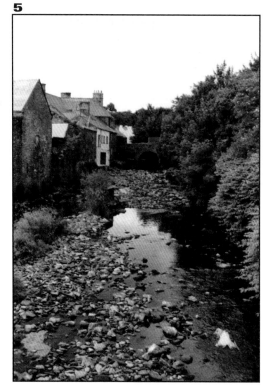

vement and fluidity. Although it may appear just to be white, do not be fooled, waterfalls tend to hide many different shades behind their deceptive uniform appearance. If the cascade is large there will be a cloud of mist and vapor around the bottom part of the cascade, this is where water hits water. The same thing goes for the ocean waves when they break against the rocks along the coast; the spray of water is generally portrayed with white paint.

6

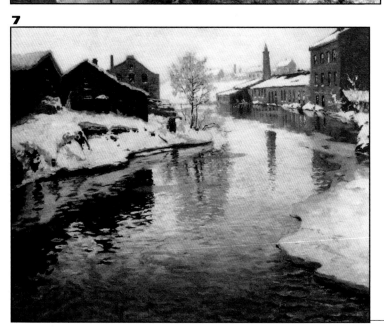

7

Fig. 5. A river is the ideal complement for a rural view like this beautiful image of a river, which passes through the Irish town of Pettigo.

Fig. 6. When you draw a river you should be very attentive to your strokes, to the rivers water level, to the vegetation on the bank, and to the color of the water. The color of the water is almost always relative to the surrounding landscape.

Fig.7. The old factory on the Aker riverbanks by Frits Thaulow (Art Collection, Lillehammer). The river follows a winding route as it descends its inexorable path towards the ocean. The surface of this work offers an interesting interaction between the light and its reflections.

Painting a seascape

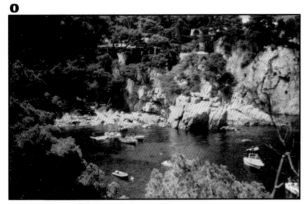

We will start off our seascape painting section by using washes. We will see how this curious method of applying color can be combined with the technique of painting over a moist surface with acrylic paint. To carry out this exercise we will count on the collaboration of artist Óscar Sanchís. The model or the reference for this exercise is the view of a few rocky cliffs along the Catalan coast which have very defined colors and forms, as well as various elements of textural interest in both the rocky walls and the coastal vegetation.

Fig. 1. First, sketch the main lines of the model with a number two pencil. Take a used toothbrush and start to splatter distinct parts of the painting with very diluted orange and blue paint; with this tool the artist obtains a well controlled wash with many small drops of paint. The process at the wash is the following: first wet the brush over the paper's surface until the bristles are well covered; after this carefully shake the brush and try to eliminate the excess water, then hold the brush over the paper's surface and rub the bristles with your thumb, with this, a spray will be created.

Fig. 2. Then, spread a layer of watered-down semi-transparent yellowish color for the shrubs, followed by a layer of Ultramar blue for the water. Notice how the blue wash sharply outlines the profile of the shrubs which helps the silhouette of the vegetation stand out and cover the first plane: this is known as the contrast of complementary colors. If we are not going to use linear elements, the best way to draw the form of the landscape's elements is by using contrasting colors; in this way, two distinct colors are juxtaposed and one converts into the limit of the other.

Fig. 3. When these clear colors have dried, more tones of medium intensity are added(burnt Sienna and burnt um-

MODELS

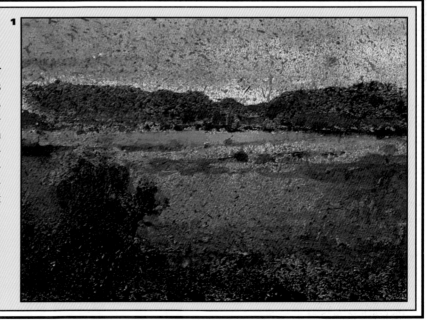

1-. *The view of an Irish lake* by Óscar Sanchís (artist's private collection). In this vision of a lake, shaded by a cloudy day, the artist treats the entire surface of the paper with a wash. The splattering and wash techniques give a marked atmospheric effect to the landscape. It seems like the lake is almost the same color as the sky; remember the reference to the mirror effect that was previously explained.

4

ber, and new wash colors of black, brownish-gray, green, and gray) to the vegetation that covers the top part of the rocky crags. Pay attention to these washes and make sure that the splattering is more violent this time, with larger spots. For the rough textures of the rocks on the right you can use a small round paintbrush. Apply a watered-down semitransparent layer of ochre orange to depict the points of light over the rocks.

Fig. 4. Now is the time to spread more washes over the whites that remain on the paper. We will cover the first part with greenish tones, then we will cover

6

the rocky cliffs, the earth, and the more intense zones of vegetation in the background with ochres, orangish, and brownish-grey tones. The pictorial structure of the cliffs is almost abstract, but it conserves sufficient detail so that you can identify it in the relief.

Fig. 5. We will return to do more washes with new colors (burnt umber, burnt Siena, and violet) for the vegetation of the lower part of the image. When you paint the shrubs at a short distance, I recommend that you practice the wash with a bristle brush instead of a toothbrush, so

that the splattering will be rougher, with bigger water marks –this will add more expressiveness to the work.

Fig. 6. With a small paintbrush add new marks to the vegetation because the trees have distinct and varied textures, which show a fascinating richness of details and nuances in color. To give life to the work, paint some details with dense colors so that they contrast with the more diluted and dull tones from the washes. The patches of paper that remain white will correspond to the vessels which we will add more detail to later.

5

Fig. 7. As a final touch, we will splatter a few more colors (violet, hooker green, yellow, manganese-blue, and pink) onto the vegetation of the cliffs in the background. The result will give more depth to the work, contrasting and silhouetting the first plane, and adding few more touches of color to the water. In this state, with the ocean present, as well as various textures united in an amalgam of ochre colors (emerald green, Ultramar blue, indigo, Siena and pink), we will break from the erroneous idea that a lot of artists have about water; that it is a smooth monochrome surface with barely any variation. With a small brush carefully begin to paint the details of the vessels.

7

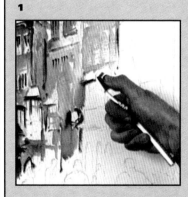

Reflections over water: an Oriental temple

Now we will deal with architectural reflections. The model is an impressive image of one of the buildings that comprises the monumental group of the Taj Majal and it shows the inverted reflection of the building in a totally symmetrical form. The artificial pond in the center is like a path of water that travels towards the mosque and reflects in a mirror -like fashion the inverted image of this building. This is an exercise that is equally as interesting for practicing the mirror effect, as it is to practice dealing with the symmetry of a painting. The French artist, Jean Diego Membrive, is responsible for explaining this exercise. Oil paint is the medium that will be used.

Fig. 1. To begin the artist will color the medium with a wash of English red diluted by turpentine. The canvas boards that they sell for oil paint are normally white, but sometimes it is useful to

2

apply a background color before starting. Some artists find the white surface to be bothersome, they say that it is more difficult to judge the clarity and the darkness in regard to the primary colors. The picture was defined by a small round brush and a burnt umber, slightly diluted in turpentine. In order to make a symmetrical composition it is advisable to paint an axis in the center of the canvas to assure that the two halves are completely equal. It may be

necessary to use a ruler or a strip of wood to trace a few straight lines.

Fig. 2. Prepare a mixture of white and turquoise blue diluted in a solution of turpentine as the first coat to the sky. Try to adjust the demarcation of the building and leave the color of the medium so that it can be seen in a few areas. Afterwards, prepare a mixture of zinc white and lemon ye-

0

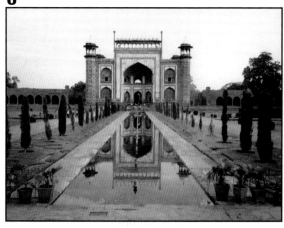

llow to cover the level form of the building's façade, and its reflection on the water. Use white with a fine bristled brush to make a few of the decorative details clearer. In this initial phase, the artist works his colors fairly evenly which is a good choice for this kind of work.

Fig. 3. The artist has superimposed a new layer of blue paint on the sky. This color is a mix of Ultramar blue, and carmine, and like you can see, the color was inconsistently applied on purpose. The decoration of the façade remains defined, and the artist started to darken the shadows of the entrance arch and its reflection with dark browns. With Naples yellow the artist goes over the ligh-

MODELS

2

2-. *The fortress fountain in Segovia* by Joaquín Sorolla (private collection). Architecture and water are two elements that have often been paired together. Together, they form an attractive combination. The beauty of the facades located near a pond are multiplied by two, thanks to their reflections. The architectural details are projected vertically over the water, which means that we can see the same work from another point of view.

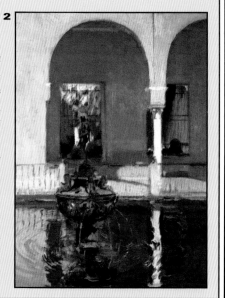

ter zones of the building. For the rest of the architectural constructions the artist uses a burnt umber to uniformly cover both sides of the main building. Any new intervention in the façade should be repeated in its reflection.

Fig. 4. With this detail we can appreciate how the artist used a small round paintbrush to define the façade decoration. When painting this type of architecture it is important to be very attentive in regard to the proportions, the forms that are present at the openings of the building, and to the ornamental details or changes of pigmentation in

4

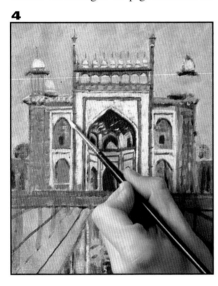

the façade. In this case what deserves the most attention are the unique forms of the two lateral towers and the gallery of arches that crown the façade. Try to make both sides look equal.

Fig. 5. In this part, the artist has finished the upper half of the work where the shrine and the sky are. The sky has been represented evenly with just one color: between celestial blue and a clear turquoise. The final result of this area is very refined and adapts to the type of work. A round brush was used to define the decoration of the building with a mixture of white and lemon-yellow. The tower's pillars were defined with a dark orange and the building's doors with a

3

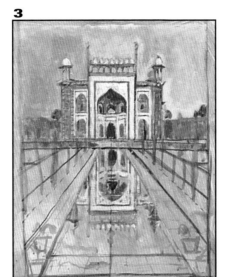

blackish color. The brick wall was refined with small strokes of texture. The trace of vegetation that shows from behind was refined with cinnabar green and cobalt, and small short brushstrokes were used to represent the leaves.

Fig. 6. We will continue to use permanent green mixed with a little bit of clear ochre for the first attempt at painting the garden vegetation. Start to cover the row of trees and add a touch of greenish ochre. The trees have been expressively defined with free agile strokes and without an apparent direction. Continue constructing the reflection of

5

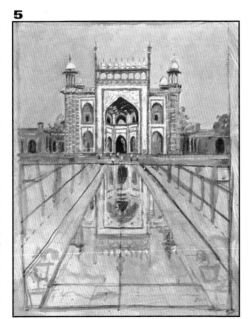

TIPS

3-. The background wash made simple: we apply a diluted acrylic or an oil paint mixed with turpentine over the entire surface of the painting and in a few minutes it will be dry and ready to paint. It is common to select a neutral color, like gray, blue, ochre, or brownish-gray.

4-. The painters who tend to work over colored backgrounds always have various canvases at their disposal, prepared with distinct background colors. Then they only have to choose the most appropriate form and color for the chosen subject.

3

4

5-. The small round brush is very useful to sort out details. This brush can become fully absorbed with paint and adopt a more pointed form, which is ideal for works that demand precision.

6-. Leaving the borders well marked eliminates confusion and a mixing of colors: the color turns out to be much prettier if you use one stroke and let it dry naturally instead of applying many strokes with constant movement over the surface.

5

6

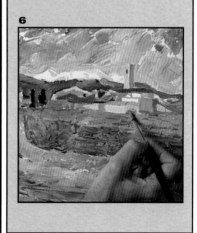

6

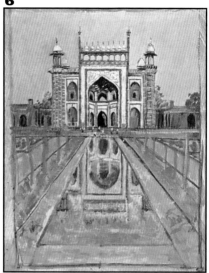

the building in a more definitive manner and use the same colors as the real model with gray, and off-white tones. The reflection is more out of focus, more toned down, and has less contrast than the building. Once at this point, the reflection has the necessary characteristics to convince us that it is water.

Fig. 7. We will analyze more thoroughly how the artist managed to portray this reflection on the water. The artist was able to create a dense layer of similar colors that melt into the image of the façade, by using yellowish and pale gray brushstrokes. He also drew the stream of water that flows vertically and the droplets that dance on top. He depicted a small jet that was in the first plane. The vegetation appears very synthetic and densely painted. The surrounding grass is a green cinnabar that consists of two or three different tones, and the trees have a dark green

cobalt tonality.

Fig. 8. The work is almost finished. With dark cobalt blue the artist darkened a few parts of the reflection at the entrance of the building. He used an orangey-brown to outline the profile of the upper part as well as a few details along the side the columns, he drew the central water jet and darkened the greens from the row of trees. He conserved the background tonality to frame the floor tiles of the artificial pond; he only added a few light green and white transparent layers to represent the texture of the material. The work is regaining liveliness and the definition has considerably improved.

Fig. 9. To finish, the artist paints the flowerpots that decorate the side of the pond, and darkens the water jet with cobalt blue and black. The reflection of the sky on the water presents a clearer tonality and the grass on both sides contains various shades of light green and yellow. Also, notice how the oranges that appear in the reflection of the façade are grayer now, and how the chromatic tendency has become cooler, which has increased the intensity of the

7

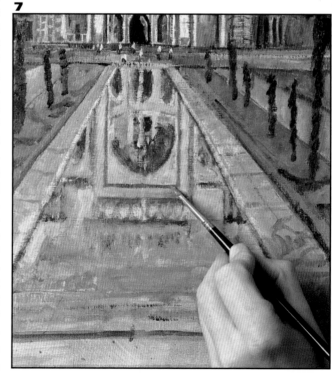

MODELS

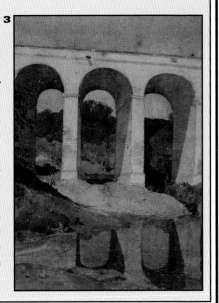

3-. *The Chirk aqueduct* by John Sll Cotham (Victoria and Albert Museum, London). The architectural elements of landscape that are most commonly reflected over water are bridges and aqueducts. This is perhaps one of the most well-known aqueduct paintings. The artist was not satisfied enough just to paint the aqueduct in a monumental and majestic manner, but he also wanted to prolong its magnificence and its charms as seen through the water's reflection. It is as if the image of the bridge not only defines the surface of the river, but also lives within its waters.

8

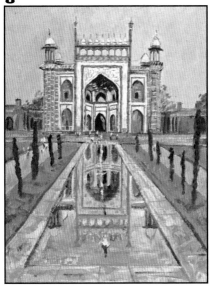

reflected image. The artist also added a few touches of dark scarlet green to represent the bushes that are further away and he added dark shadows to the treetops. In order to separate each of the tiles, he used a neutral color and lightened the parts that are closer to the observer. The final appearance of the work is clear and vivid because of the colors and tones used by the artist in this exercise.

9

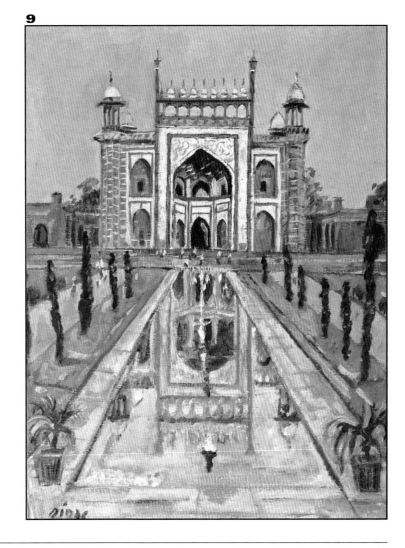

Reflections on a lake

0

How many times have we seen photographs of lakes and fir forests that reflect an inverted image of a precipitous snowy mountain? It is a common image often found on promotional posters for mountain tourism centers. It should not seem so strange that we have chosen a similar image that offers numerous pictorial possibilities to include in our book. The scene that we are going to paint now is of a high mountain lake during a hot summer day. As you can see the reflection is almost perfect, which makes it easy to confuse the real image with its reflection. This time, artist Teresa Valverde will paint for us, using watercolor as her medium.

1

Fig. 1. After choosing an absorbent and resistant paper, she mounted the paper on a wood board with adhesive tape. In this manner she was assured that the paper would not warp when wet. Before starting she made sure that the paper did not wrinkle and that it was stretched as tightly as possible. Then she moistened a sponge and rubbed it over the pa-

per's surface. She did not let pools of water form; the water should be distributed evenly. Once the paper is wet, the watermarks scatter and their boundaries diffuse. This is a technique which achieves a much more realistic effect.

Fig. 2. Start defining the shadowed part to the left of the mountains with a gray diluted tone and add cadmium yellow to the center to establish a region that is brighter where the mountaintops will be drawn. The marks should be very faint at first because it is important to work gradually with the intensity of the colors. See how the color marks widen and become clearer while they dry. Define the dark center zone of the mountain with a violet blue, and use a few light brushstrokes of a more intense blue. Wait until the paper has completely absorbed all the water to begin to paint the sky. Make a mixture of turquoise

2

MODELS

4

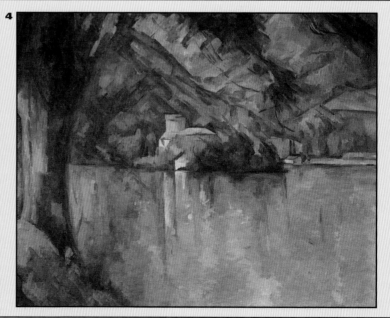

4-. *Annecy Lake* by Paul Cézanne (Courtauld Institute Galleries, London). Here the painting of the water is not as fluid as in the exercise. Both the reflections and the distinct parts of the painting have been treated with a structural method. One chromatic harmonization based on greens and blues dominates the entire painting, giving the composition a cold and calm appearance. In the reflections the artist used a vertical brushstroke but the distinct marks of tonality that are seen on the surface of the water are all horizontal. Do not forget that the direction of the brushstroke helps to explain the volume as much as the texture of the forms.

3

and celestial blue to obtain the blue of the image. With a medium amount of water and certain agility, start to paint up and down. To gradate the blues deposit more color on the upper part and water down the surface while following the descending brushstrokes. With this system you can obtain the gradate of the image.

4

for the shadows. Remember that you should establish a horizontal axis in order to paint the reflection over the water; the reflection should be almost an exact replica of the real image. The actual lake acts like a mirror, and the colors between the image and its reflection do not vary much. Observe how the artist has finished the shadows on the peaks; with large and loose brushstrokes of blue-gray paint of medium intensity, with fairly uniform marks, and hardly any tonal gradations.

Fig. 4. The whites of the medium have been lightly muted with dull washes

Fig. 3. The following step consists of darkening the shadows of the mountains. The artist uses a mixture of Payne gray and cobalt blue to establish the value of the shadows to the left. She also added a few violet and ochre transparent layers to the most central part. She used dark tones of Ultramar blue, ochre, Payne gray for the rocks and the bushes in the center, and burnt umber

mixed with a little bit of blue. Now the work has a certain atmospheric character and the elements are more defined. The artist has enriched the greenish and bluish tones of the central shadows. She has darkened some of these in order to establish a greater level of intensity. With a large moist brush she blurred the profiles of the peaks in order to unify them more with the sky.

5

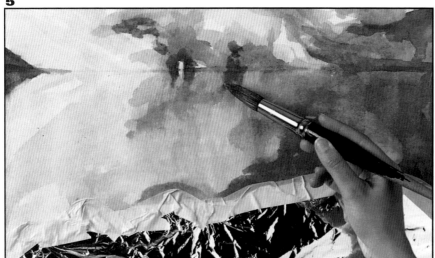

She used pale violet-grays for the brighter part on the right, and other yellowish tones for the central part. The reflections should be worked with at the same time as the rest of the landscape, and the colors should repeat themselves in more than one spot, although the colors used for the water should be more diluted.

Fig. 5. Then, the artist starts to add detail to the reflections of the lake. For this she placed the work upside down so that she could work more comfortably, and the work would come out more clearly. To avoid accidentally marking a part of the sky, she hung an improvised mask of aluminum foil and adhesive tape over the area. Through the yellow and gray-ochre transparent layers she established a generally warm range of colors that contrasted with the dark blues and greens. You should not forget that each application of color modifies the previous –you can use this as a method to mix colors.

Fig. 6. In this phase the artist darkened some of the shadows to the left and was able to create a larger contrast. Little by little as you continue to bring new more intense values to the work, the work gains volume, precision and depth. Notice how the crest of the mountain to the left is much darker and contrasts with the sky. The artist has also defined the horizontal axis, which divides the real image from the reflected image with a thin violet line. The trees and the bushes that make up the vegetation are suggested through vertical brushstrokes of cinnabar green and yellow. She added earth colors and yellow ochres to the left part of the painting, where the mountain is more shadowed. These last contributions are ap-

6

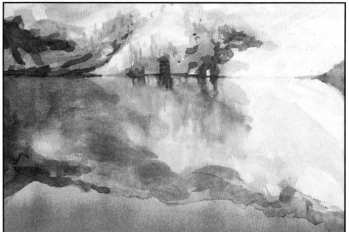

MODELS

5

5-. *The four trees* by Claude Monet (Metropolitan Museum of Art, New York). In this composition the artist divides the scene into thirds, which means, he situates the line of the reflection at exactly one third of the height of the medium. This measurement is not made at random, it is based upon a golden rule well known amongst classic artists. If the line is situated directly in the middle we can make the composition symmetrical, which will later make it difficult to distinguish which part of the painting is the reflection and which part is real. When the painting is divided into thirds, it becomes evident which of the images are real and which are part of the reflection, that is, if the artist has treated the vegetation of the upper and lower parts in exactly the same manner.

7

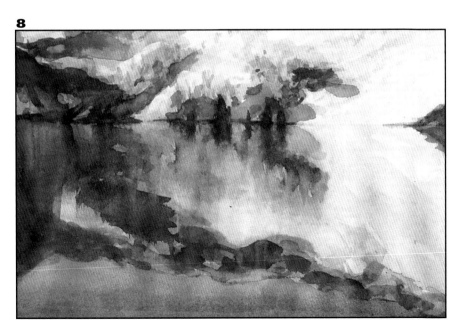

plied gently, without permitting breaks in color that would interrupt the unity of the work.

Fig. 7. Aside from the intense transparent layers, the artist progressively continues to darken the mountain's shadows and its reflections on the water. The nuances continue to be the same, but they have more saturated colors. Notice how the right area of the work contains more pictorial density. She applied veils of pinkish-gray and pale yellow to the part of the reflected image that is illuminated by the sunlight, and she accentuated the blues of the peaks in order to make them stand out. You can see small brushstrokes of dark blue cobalt on the reflected part to the left, and other more purplish strokes in the surrounding area. The work gained density and contrast, and now,

appears to be better defined. You should also be aware that the modifications from the upper half of the painting should also be repeated in the reflection.

Fig. 8. Before continuing, the paper should be left to dry in order to avoid the blurring of colors, and then it should be painted with a very controlled wash, intensifying the earth colors and the brownish-gray color at the center of the composition. With a dry background, she paints dark violet colors onto the upper area of the mountainous walls, as well as the shadows of the rocks along the shore of the lake. The vegetation smudges a little with a moist brushstroke. In this manner, the work is finished looking much more pictorial and realistic. Other details like the bluish reflections to the right have been achieved through a mix of Ultramar blue and burnt umber. Now, the work is finished; the lake acts like a mirror and the mountains are inverted in the reflection. We can see how the successive transparent layers of color differ from opaque paintings; here you can obtain colors of great depth and richness.

TIPS

9-. Over a moist background it is easy to open white spaces; this can be accomplished just by passing a clean brush over the surface, washing it, and repeating the process.

10-. The greatest difference that separates the masters of light and shadow from the mediocre artists is the aptitude the masters have to express with little light the forms of a dark object, and with little darkness the form of a lighter colored object. It is better, to leave the forms how they are, unsatisfactorily reproduced, than to loose their general relation to the big picture.

9

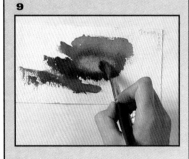

10

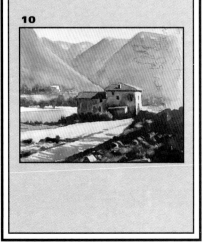

8

A boat ride on a pond

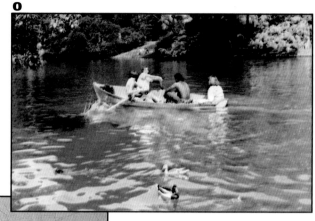

Before we painted calm lake waters, but now we will try to paint a pond with a recreational boat. The interest in this exercise lies in the altered surface of the water after the rowboat has passed; the reflections of the nearby vegetation seem to suffer a large deformation, giving way to the appearance of luminous reflections over the ponds surface. The quantity of greens and the richness of the reflections that these waters possess are what motivates painters to try to effectively and sensitively paint the image. We will count on the help of the painter, Antoni Messeguer to help us execute this exercise. The medium will be acrylic paint. It is recommended that you practice this exercise at home and pay careful attention to the following indications.

Fig. 1. The first fundamental step consists in establishing the base color of the medium so that it suits the desired effect. In this example, the artist opted for a medium blue tone. Next, using a graphite bar, he made a sketch of the basic lines of the composition including the location

and form of the most significant elements. He made a linear and schematic sketch of the boat and the people inside the boat; he only outlined the profiles of the background vegetation with suggestive marks; and with a more calligraphic style he defined the contours of the ducks. These lines will serve as a guide for the following colored marks.

Fig. 2. We will go ahead and put down the first few colors on the canvas. In this first phase of staining, the artist works in a very structured manner. He resolves the shadows of the background vegetation with washes of intense turquoise blue. The middle part is filled with brilliant colors, mixing slightly between them. When the colors come directly out of the tube, they present little intervention and little value. They may appear to have little relevance to the colors of the model, but do not worry, try a simple approach, learn a few simple referential values At the end of this exercise, the author will talk about a range of apparently "fauvist" colors to demonstrate the values that are present in this subject matter.

MODELS

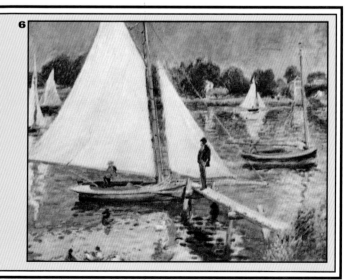

6-. *Candles on the Argenteuil Seine* Auguste Renoir (Portland Museum of Art). Vessels navigating over water was a very important theme for the impressionist painters; they saw it as a good opportunity to study the effects of light over a surface of water, altered by the passing of boats. Renoir played with small nervous strokes over the water, adopting one stroke that was more fragmented and one that was more fluid. Look at the detail, the reflections have a greener tone than the real image, and also compare the white color of the sail with the color of its reflection.

3

Fig. 3. The artist continues to work on the painting in a structured manner. He makes new contributions with a large flat brush, working in sections, and superimposing new color marks on top of the old marks, which, little by little brings the color closer to that of the actual image. What was initially red transforms into a cluster of orangey marks; in water a range of greenish co-

Fig. 4. With a softer smaller brush we will continue to define the marks from the last step. The brushstrokes for this brownish zone should maintain a horizontal orientation that will contribute to the virtual effect of the water. A few dark red strokes are applied to the remote part of this area, and a few of the reflections are defined with some pale tones of ochre. The brushstrokes should follow the direction of the water's undulation. With a very pale yellowy-green a section to the right was covered, and with dark green cobalt some of the dark parts that describe the contours of the people in the boat were defined. The light and luminous tones can be more easily perceived when the

4

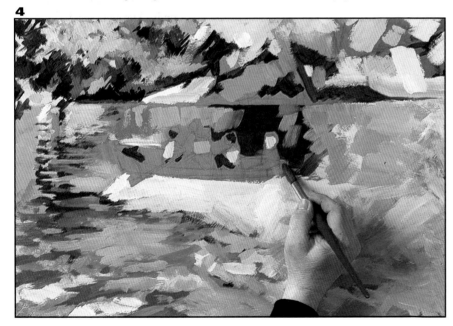

lors saturated with yellow, ochre, and white are juxtaposed. The background is also full of brushstrokes, and the colors from the first layer are repeated. The way this artist works is reminiscent of the short juxtaposed strokes practiced by the impressionists.

background has been stained with a medium tone.

Fig. 5. Now it is time to paint the people inside the rowboat. Like the rest of the composition, the figures have been dealt with in a schematically and structured manner, that is to say, a skin co-

MODELS

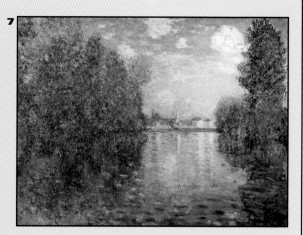

7-. *Autumn in Argenteuil* by Claude Monet (Courtauld Institute Galleries, London). Notice the interesting method that Monet used to resolve the surface of the water. First, he accurately painted the reflection of the trees over the surface of the water with shades of ochre and brownish-grays, and then he started to extend in a conscientious way, the blue of the center part of the river onto the reflected image of the trees. The way to integrate the reflection with the water is to apply a series of short brushstrokes, juxtaposed, and equally distanced, on top of the reflected image. He tried to continue covering the image of the tree over the water with the same color that he used to paint the river. The result is surprising.

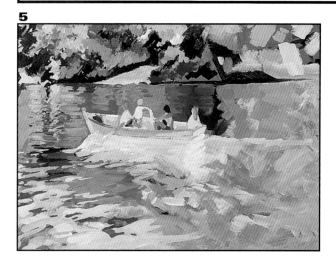

lored mark for the face, another color for the shirt, a bluish application for the pants, etc... The paint is best to work with when it has a medium consistency. A series of brushstrokes have been applied to the background vegetation and the surface of the water. As the drawing advances, the forms become smaller and more concrete and although the pictorial structure of the surface is almost abstract, it still preserves enough detail so that the undulations of the water become more defined.

Fig. 6. With a small round brush the short horizontal brushstrokes are applied to the surface of the water. The local colors are adjusted, they are painted with more value so that the background reflections continue to gain intensity. The vegetation already presents itself in a more formal and structured manner. With new applications of light blue on the first plane the crystal-clear consistency of the water is painted. Notice that the initial coat of Ultramar blue is completely covered. With small strokes of granite and dark brown, the artist created a dark reflection near the boat, and

with a greenish brownish-gray he defined a few reflections on the lower left part. He will now try to represent the alteration lines- the trail that the boat leaves as it moves through the water. Fig. 7. With a fine brush the artist starts to add details to the ducks with a whitish-yellow color. It is important to capture the color and characteristic posture of the ducks. Ducks naturally stay still during long periods of time which facilitates the work for the artist. A brownish-gray pink tone was also used to define the eyes and the wings of the ducks. The brushstrokes become smaller and narrower as we further add detail to the water; this creates more detail than in the first plane. This is a photographic resource which is also habitual in the field of painting, that is, to make the first plane more imprecise and out of focus than the background. The reflection of the boat with the people is seen quivering upon the water's surface. On the first plane, you can see distinct tonalities of light celestial blue; some are more purplish and others more greenish, and if we close our eyes a little, this part will appear like the reflections in the lower part, lighter and more alive.

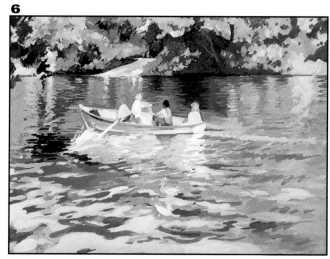

7

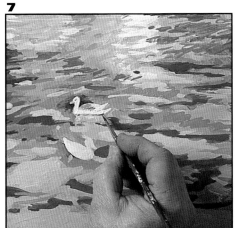

Fig. 8. The most precise details are saved for the last phase in which we will finish defining the details of the background. The vegetation already has the proper texture, the artist finished painting the branch (which appears in the upper left part of the painting) as if it were on the first plane. He added details to the trunks and to a few trees to-

wards the back with dark cinnabar greens and ochre colors. He used a pale pink-brownish-gray for the boat's border, and with the same color he further defined the specks of background light. The artist recreates a feeling of placidity that the image should transmit, as well as a certain amount of virtuosity in the waters. The large loose brushstrokes on the closest part of the water give us the feeling of movement that you normally see when a boat passes by; and this contrasts with the background calmness. Notice how the work presents an interesting chromatic harmonization through the greenish reflections. The entire composition is linked through the repetition of the green color of the vegetation in other elements; for example, there are those that stand out on the boat which are created by lighter and pinker tones.

8

Painting Marshes

In this exercise we will try to capture pictorially the muddiness of the marsh waters by using shadows, reflections, and the remains of the vegetation that floats on the surface. This subject matter presents us with a first plane that has hardly any landscape or depth, only water and a strip of course and broken vegetation. This time Carlant will guide us through this exercise; he usually works with paint in the valorist manner. Step by step we will see how to achieve the quivering reflections of the vertically sunken sticks, and how to deal with the surface light that reflects a sky with interval cloudiness. Oil painting will be used for this exercise. Are you ready?

0

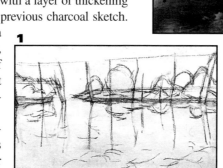

Fig. 1. After properly preparing the paper with a layer of thickening solution and Spanish white, return to the previous charcoal sketch. With this you want to have a sketch with a clear motif. This should be a quick sketch, without shadows and without any kind of complement; it is only necessary so that the color has a guide and the brush can distribute it evenly.

1

Fig. 2. We prepare the corner of the palette with earthy reds, ochre, and warm colors such as oranges and yellows. On the other side we will distribute the cold colors like the blues, greens, and violets. We will place the white in the neutral corner. In this example, the artist covered the vegetation zone with earth colors, permanent green, and Ultramar blue. These three colors were mixed together and looked dull and muddy. Initially we worked with colors mixed with turpentine. It is not necessary to define from the beginning, what is important however, is that you stain and cover the principal areas. This zone will be the darkest zone of the work, which means that we have already established the maximum limits of darkness for this painting.

2

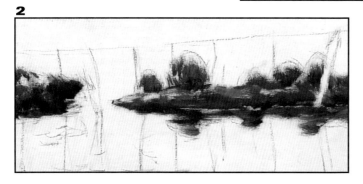

Fig. 3. Now we will paint the water. With a big 'langue de chat' paintbrush we will start to cover the large white space with mixed horizontal brushstrokes of violet, cobalt blue, ochre, umber, and green. The colors should be applied with short strokes which should fuse with the adjacent colors if you use a little turpentine. Paint with a turpentine charged brush that is almost dry, in order to allow later interventions

MODELS

8

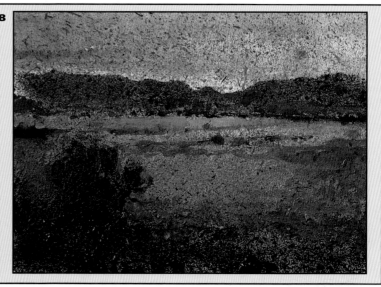

8-. *The pond of nymphs* by Claude Monet (Orangerie Museum, Paris). After 1909 he started to paint these mainly aquatic landscapes where the surface of the water is highlighted without any terrestrial references. Monet focused on resolving the reflections on the surface of the water by using close and diffused brushstrokes. The color of this work enables the viewer to distinguish the reflections of the clouds in the sky. The only reference, although treated in a very abstract manner, are the nymphs that are situated in the upper part. They appear slightly defined and outlined with some slight traces of red.

3

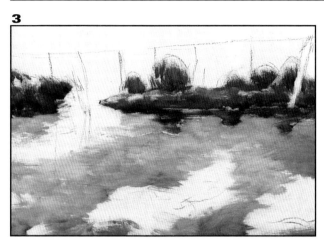

with a brush also find a turpentine color base but very dry. If the bottom is too moist, the later color applications will not stay over this one.

Fig. 4. The artist finished covering the surface with new variations of the colors mentioned in the previous step. Notice how, although it is very diluted, he has reproduced the form of the clouds in the sky that reflect out over the surface of the water. The brushstrokes follow their horizontal direction and now appear much more dense and tactile. Although there is a large quantity of nuances that can be seen in the water, the artist knows how to establish the predominant color without putting down an excess of colors. The use of oil requires a correct staining of the canvas, so that the paint

will adhere well and dry without cracking problems. For the moment, do not abandon the big brush and do not attempt to make big value contrasts; we are still in the staining and general toning phase.

Fig. 5. Once the surface of the water is defined, we will begin to define the whites. With the same langue de chat brush used since the beginning, define the large reflection of light on the upper left part of the painting, using two applications of titanium white. The brushstrokes will be applied horizontally trying to integrate them with the colors of the water, if it is necessary you can blend the edges with your fingertip. The impressionist way applies more white and uses a dotted technique to cover the rest of the water's surface. For the moment, limit yourself to applying the color evenly and opaquely but try not to go over the painted parts of the vegetation and the water. Continue using a big brush and try to apply the color gradually.

Fig. 6. Once the medium is completely covered with paint, the artist begins to

TIPS

15-. Infinite marks appear during the painting process, through superimposition or juxtaposition, and from all the different processes and materials that are used. Knowing how to mix colors well is half of the battle for an oil painter.

16-. If you were distracted and let the bristles of your paintbrush dry, you can find a product in the market which can help you to clean the bristles. However it is a laborious process, and on top of that you will probably end up ruining the bristles of the paintbrushes.

15

16

4

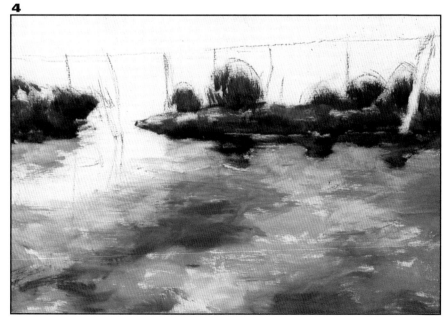

MODELS

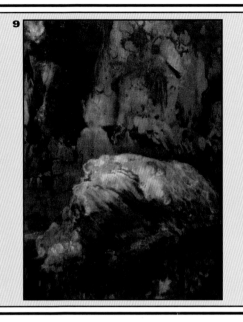

9

9-. *The rock in the pond* by Joaquim Mir (Modern Museum of Art, Barcelona). Look at the impressionist treatment of this rock in the pond. If the rock appears to be clearly defined the reflection appears more synthetic, more concise, treated with juxtaposed brushstrokes. The interest in the morphology of the rocks and caves in Mallorca make the artist try to obtain a vision of nature by using blurred chromatics, reflected through marks and touches of intense color. In this work concepts of light, color and form merge, demonstrating that Mir was an innovative artist, creator of a truly free art.

horizontal direction of the brushstroke is maintained.

Fig. 8. In this image we can see how the reflections of the water have been defined; to create interest in the lower part of the painting, the direction of the brushstroke was modified. This creates a multidirectional effect of motion, as if fish had been swimming beneath the surface. The artist also added the vertical sticks, jutting out over the vegetation line, and projecting their inverted image onto the water. The artist used bluish-gray colors so that the image would project out onto the water. The reflection is slightly darker than the original color of the stick, its outline less defi-

5

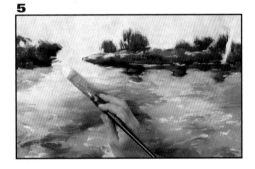

create the reflections on the water. With white and some light blue cobalt pigment he defined the sparkling of the lower central part with a smaller brush. These brushstrokes maintain the horizontal direction, but they vary in longitude. New additions of violet are used to define the large shadow that appears in the center part of the painting. He projected the reflection by using cinnabar green as the tonality. Look how the work is now more contrasted and how this has added considerably to the sensation of movement in the water. Visually the water appears denser and heavier, and with this comes a certain feeling of depth.

Fig. 7. Little by little we add new values to the water. The artist leaves aside the big brush and uses a small brush in order to initiate the last phases. With a small round brush define a few dark points far away and at a midpoint, to represent the

rest of the vegetation that floats on the surface. By using a dark brown that is slightly bluish and with short horizontal brushstrokes you can cre-

6

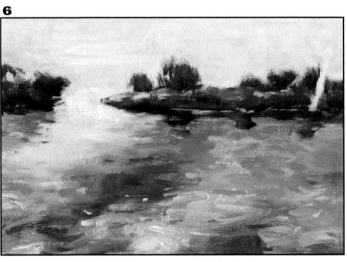

ate a distinct groups of marks on the top section of the painting. The parts that are further away should be defined with diluted and transparent colors. Do not forget that the darker and more contrast that a color has, the closer it appears These small dark brown marks help to define the effect of the water in the final plane. Observe how these dark marks present distinct irregular forms and distinct sizes yet the

7

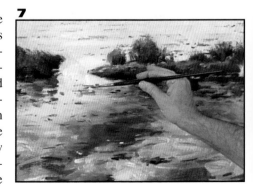

8

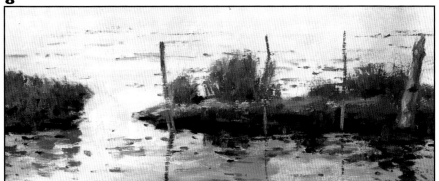

ned, and discontinued in a few parts. The artist darkened the reflections of the vegetation with a little bit of black and cobalt blue in order to intensify their contrast, and he added new values to the bushes: mainly Siena reds, and violet-blues. Fig. 9. The new sticks that the artist painted converted into interesting vertical references that contrast with the horizontality of the strokes of water. Subtle variations of white are used to cover the upper part of the work, which is the most illuminated by the sun. On the first plane of still water you can place new layers of denser color on top. These will not become mixed with the background; they should be clearly placed on top of the prior coat. Pay attention to the quality of these last strokes, they are not identical: some are short, others long, but none of them are blended with inferior tonalities. If the color is too thick, you can use a little bit of linseed oil, but the quantity of oil should be minimal in order to avoid the color from becoming too fluid.

9

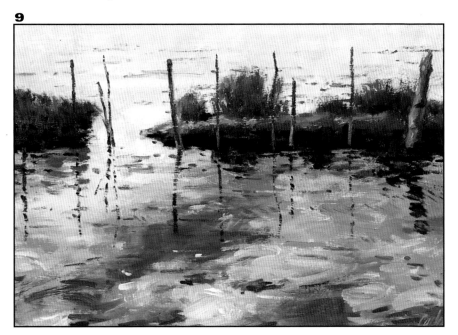

TIPS

17-. Remember that dense paint has a strong physical presence and that it produces and appears more obvious. If you want to maintain the depth of the composition, save some of the denser paint for the first plane or the central point of interest.

18-. The true difficulties lie in correcting the refinement of the forms and the regularity of the gradations. Believe me about this. If you are unsatisfied with your work it is probably because it is too crude or too irregular. Maybe it is not bad, but the borders of the silhouettes are not accurate enough, and the shading is stained or scratched, or the painting is full of white spaces. Paint more tenderly and more truthfully and you will see that your painting will strengthen.

17

18

Ripples in the water

In this exercise you will learn rapidly and efficiently to convincingly reproduce the effect that is produced by the impact of a form on the waters surface. We can see this effect through the concentric circles that are formed and expanded over the calm surface of the lake. Ester Llaudet will take us through this work with watercolors and reserves of liquid eraser.

Fig. 1.Whenever you use watercolor to carry out an exercise, it is a good idea to tighten the borders of the paper over a rigid board. In this example the artist has opted for a slightly textured paper that is quite absorbent. Remember that the final

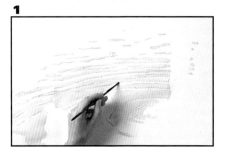

result of the work depends a lot on the quality of the paper. To begin, the artist drew the waves in the water, and then covered the light parts with liquid eraser. By putting the liquid eraser, we are assured that this area will remain unpainted. This part is delicate and you have to adjust its drawing a lot, and then leave it established in the composition of the work.

Fig. 2. Once the reserves of rubber have dried you can start to make marks on the upper left corner with the large round paintbrush. Use a lot of water and mix cinnabar green with one part of ochre and yellow. Start from the top and spread the color in a homogenous way, without allowing the pigments to collect

too much along the borders. These greenish colors will represent the reflection of the vegetation that we do not see, that stay on top of the water. They act as if they were sweeping the color with an abundance of water; in this way, we can diffuse the colors and create gradual transitions.

Fig. 3. Without waiting too long the artist begins to use black to create a contrast between light and shadow that is seen on the right side. For this step she used a large brush. In some areas the black appears

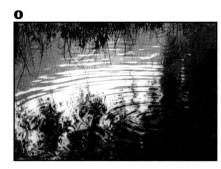

completely opaque (lower right corner) while in others it appears gradated and bleached (lower left part). In the upper zone the black gradually mixes with the loss of the illumination, in this manner, abrupt transitions of color are avoided.

Fig. 4. Once you arrive at this point it is necessary to remove the rubber in order to continue working. To do this you will have to wait until the paper has absorbed the water and has completely dried. Use the eraser and rub it over the zone that

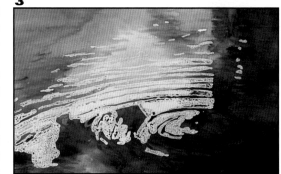

MODELS

10-. *Rossignol Lake* by George Luks (Munson-Williams-Proctor Institute). This is an example of a way to treat the waves more synthetically and expressionistically. Instead of presenting a realistic representation with the entire characteristics well defined, she captures the vibrations of the water's surface with an amalgam of undulating brushstrokes. One is placed on top of the other so that the water is converted into an interesting abstract representation. To emphasize this effect the artist places the vessel on the upper part of the work where it does not take away from this effect. In this manner, the man and the boat convert into secondary motifs and do not completely occupy our attention.

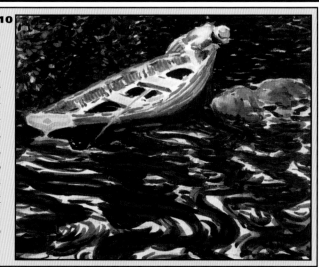

4

was previously covered with rubber. You will see how it unsticks with considerable ease unveiling the initial white of the paper. It is not advisable to use your fingers or nails because they contain greases that could permanently

5

mark the paper. Once the liquid rubber is removed we will see the reflection produced by the waves on the water. In this state with an important utilization of colors, we have already achieved the principal effects of light over the surface of the water.

Fig. 5. The artist used undulating

6

brushstrokes to represent the tree's leaves that are reflected onto the water. This work can be accomplished by using a small round brush and with a very diluted black. These black marks present small contributions of carmine and ochre. This serves to muffle the effect of the white of the paper, to break its excessive stridency. The reflection of the vegetation is modified with a fan brush in order to subdue the forms a little; it is not recommended that these brushstrokes are very marked.

Fig. 6. In this last phase more subtleties were added to the reflections, and the darker reflections of the work were clarified. With a moist brush the artist continued opening the whites of the watercolor in order to achieve intermediate reflections. The lower part of the work is now full of shine and the clear reflections that we have obtained through this method of absorption. While the watercolor of the background is still damp the branches that jut out into the upper part of the painting were painted. For this step a fine brush charged with a mixture of green cobalt and black was

TIPS

19-. If you want to open up the whites in the painting, first you should loosen the paint by passing a wet brush over the area, then you should pass over the area a few times until the color has been eliminated. It is precisely during these types of practices that the quality of the paper is the most important thing; a good quality paper enables the work to be meticulous, but it is possible that a lower quality of paper could not be cleaned in such a proper way.

20-. If you want to work quickly, you can accelerate the drying process of the watercolor with the help of a manual hairdryer. You do not have to bring the hairdryer so close so that the drops of color run.

19

20

used. While the last watermark was still damp, part of the colors extended to form a sort of gray aura that enveloped the form of the leaves.

Painting a stream

Here we have the landscape of a tall mountain with a river in the Huesca Pyrenees. This is a subject matter that calls attention to its composition, its coloring, and its contrast, is ideal to be painted with a range of uneven colors, that is, a range of gray colors that are of extreme importance when working in a valorist fashion. In this work, the true dominant colors will be brown and gray but there will be other colors also, not too many so that the painting will turn out dull. Ester Llaudet, an excellent watercolorist, will guide our steps during the development of this exercise. As you could have guessed, watercolor will be used during this exercise.

Fig. 1. This landscape starts with a simple pencil sketch that indicates the general position of the mountains, the trees and the current of water that descends until it reaches the first part. Take into consideration that we are going to paint with watercolor, this means that the first drawing will be linear, that is to say that it will be ignoring any tonal representation. You should avoid representing the shadows with grays, opposite from graphite; we should mix it with washes of watercolor and dull the colors.

Fig. 2. The artist starts to work from the center of the painting. In order to paint the intermediate areas, first you need to spread a wash of ochre a little gray. Observe how the wash is not completely even; some zones are more greenish, others are more crimson and others grayer. Then, get a small pencil and over a moist area paint with a mixture of chromium green, cadmium yellow and burnt umber the bushes and the few weeds that cover this space.

Fig. 3. Now with a medium brush paint the mountain that appears more distant, that dominates the central part of the scene, with a medium gray. Behind the general washes, paint the space with a small brush defining the appearance; this will hardly vary during the course of the

o

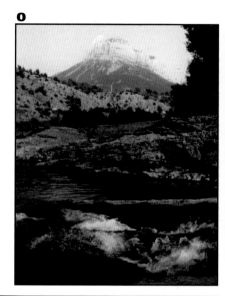

1

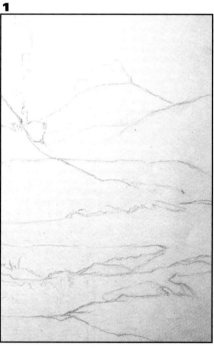

2

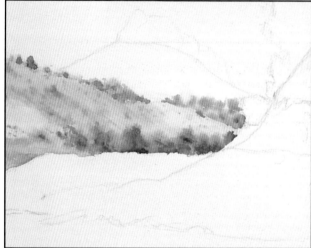

3

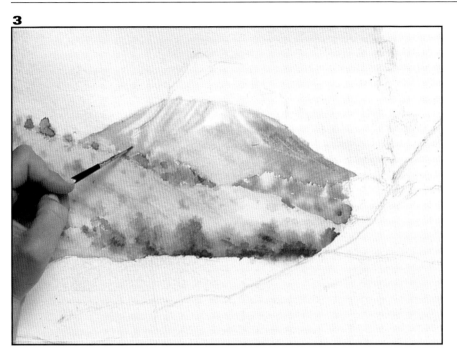

work. To deal with the perspective of the mountains, gray and blurred colors should be used, with hardly any

4

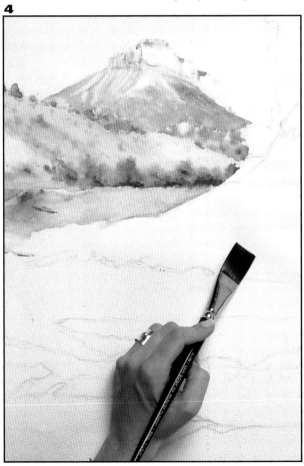

contrasts, and hardly any details to the vegetation.

Fig. 4. With a flat clean brush wet the paper, just like the artist did in the illustration. Try to prepare the surface so that you can paint while it is moist, that is, paint like you were painting before, continuing to paint before the previous wash dries. This technique of painting onto a moist surface creates a very dramatic effect that allows the colors to expand in a natural manner over the surface of the paper, blending into one another, and creating interesting fading effects.

Fig. 5. Continue defining the group of trees to the right. First apply with a medium brush, a coat of uniform color

TIPS

21-. It is advisable to make a few preliminary sketches of the subject matter that you want to paint by separating sections into planes and imagining the definitive framing that you are going to give the painting. This type of preliminary exercise will be a great help when it comes to defining the ideal interpretation of the definitive plan.

22-. If you are working in a very warm and dry climate and the washes are drying too quickly, preventing your work from developing how you would like it to, spray the paper with water in order to keep it moist.

21

22

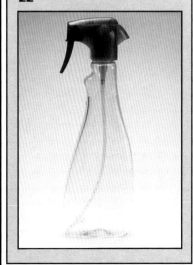

(emerald green with a hint of Payne gray). With agitated and brisk hand movements, you can represent the texture of the tree's leaves, giving them this typical irregular profile. Notice that between the branches there are small light white sections where you can see the white of the medium; these small spaces are used to represent the spaces that are usually penetrated by sunlight.

Fig. 6. The work follows its course by descending the surface of the paper to the rocks; do not forget that the surface should remain moist. First spread a layer of subtle watery gray-brown, then place new washes on top that are a little more saturated with color. This will represent the morphology of the rock, and the impact that the light has over the terrain. Make sure that when applying this second layer, that the distinct colors run together over a moist surface and create marks which are irregularly contoured, imprecise and blurry. All of this should be painted rapidly in order to prevent the previous marks from drying.

Fig. 7. Dealing with water is perhaps one of the most difficult parts of this exercise. Start by painting the calmer zone, staining the paper with a diluted gray wash. While you let this initial wash

MODELS

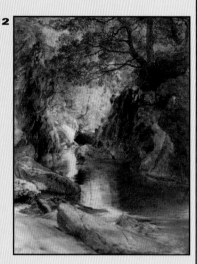

12

12-. *Waterfall in the shade* by Samuel Palmer (private collection, New York). This landscape of a river demonstrates what was explained in the first part of the book; riverbanks tend to appear half shaded and half illuminated. The surface of the water has been created with horizontal brushstrokes, which are more apparent in the illuminated zones and more dulled in the shaded zones. For the rocks we combine dramatic washes with the linear structure which is applied with ink and nib.

5

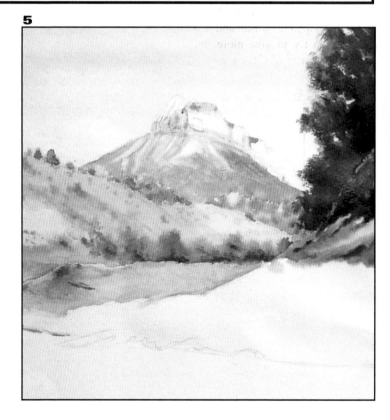

dry, get a medium brush and add a little Ultramar blue and Prussian blue to the left side, along the margin of the paper. Define the intermediate zone with the same color but do not use so much water in the mixture. Leave little white spaces where you can see the color from the previous wash to simulate the light. Remember that when we paint a stream or a river one bank will always be darker than the other.

Fig. 8. Now paint the riverbanks. Add details to the area where the

6

7

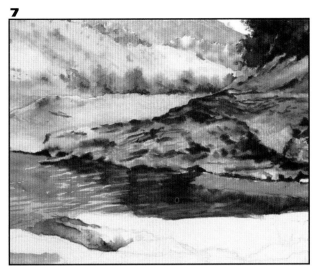

water flows from the submerged rocks and creates foam. We will achieve this effect by leaving the paper white. Apply small brushstrokes of semitransparent white and Ultramar blue to try to give more movement to this part of the current. Add

burnt umber and a little more Ultramar blue to paint the shadow of the rocks, and to make the white color of the foam stand out more. Intense gray stains represent the submerged rocks that are not visible.

8

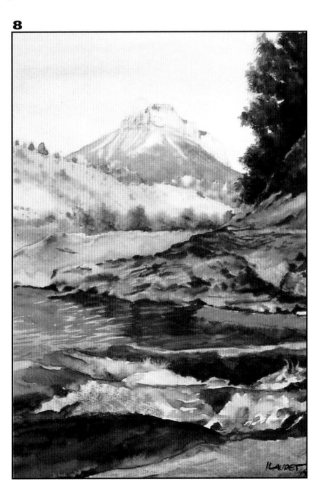

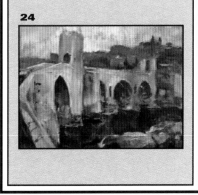

Painting a fountain of water

We are now going to practice painting a water jet, which is one of the many different effects that water can produce. The dispersion of water is an interesting effect; millions of tiny drops of water appear like tiny precipitating sparkles, creating drawings in the air. Their representation may appear complex, but after this exercise, you will discover that the jets of water are easier to paint than they appear. Marc

Calvelo will once again guide us through this simple yet attractive exercise by using oil paints.

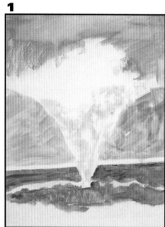

Fig. 1. For the first layers of paint apply a gray-blue for the sky, umber for the vegetation in the background, and a Prussian blue with one point of brown to the pond water. These first tones are used only to stain the background. In this first intervention, the colors are very watered-down, and the white background of the canvas shows perfectly through the applied strokes. For the first coats of color

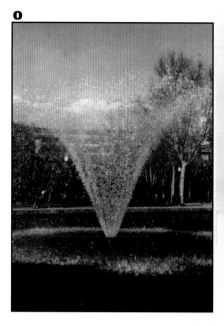

you should not go into too much detail, nor should there be a true intention to define the forms. It is more important to place the first registers on each zone than to try to establish the colors In this manner we can identify the form of the water jet at the bottom.

Fig. 2. We will finish covering the surface of the pond water with ochres, brownish-grays, and Prussian blue. Notice how the white creates a circle which depicts the foam that generates around the falling water. The artist paints the sky with a mix of Ultramar blue and white. The layers of color become more concrete as more progress is made with the painting. Do not worry if you cover the initial drawing, we will recover it later on. Now, we will try to completely cover the sky. Note how the color has not been uniformly applied; the celestial blue forms a light tonal gradate, a little darker than the upper part of the painting.

Fig. 3. The artist softened the brushstrokes on the pond's water, lightly blurring them. With successive additions of color, the vegetation in the background has been defined. First, the artist applied permanent green, cadmium green, Siena, ochre, etc… The marks for the

MODELS

13-. *The fountain* by Josep Antoni Domingo (artist's private collection). This is a pastel of a sculptural fountain which is comprised of various jets which give an air of importance to the sculpture. The drops of water have been made with hesitant strokes of white. Notice as the pool rises, that it dissipates into small drops and the stroke transforms into a dot. Remember that the jets of water will have clear repercussions on the surface of the fountain water; the falling of the drops notably alter this surface. We can resolve this by using various tones, concentric strokes (simulating the waves), and white streaks to simulate the foam that results from the impact of the jet.

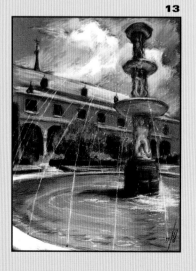

3

Fig. 4. The artist continues working on the background. With a small round brush the branches of the trees to the right are brushed with a mix of

4

Siena, carmine, white, and one point of ochre. This unevenly proportioned mixture will create a tonal variance that is present in the trunk and the branches. Finally, we will deal with the first plain, we will paint the pool of water; you already know that water in motion should be represented with white streaks. In order to paint the water near the pool we will drag a slightly inclined brush full of white paint across the surface. Dots can be used to depict the rising of the water.

vegetation should be applied progressively, each time more concretely so that they become established in the painting, even when they are covered by new denser brushstrokes. The forms in this painting are constantly being redone thanks to the spreading of the color inside the corresponding forms. With a langue de chat brush we will carry out the last step on the sky to represent the cluster of clouds.

5

Fig. 5. The dots are spread in a concentric fashion in order to represent the dispersion of the drops. In the lower central part of the pool we will add more ochre colored dots to simulate the transparency of the water and create patches where we can see the colors of the bottom. The water of the pond can now be considered finished. The artist made the surface even bluer by adding grayish Ultramar blue. Then he used a small brush to paint white splashes in a circular form on the surface. In order to achieve the saturated effect you must apply a considerable amount of small white dots.

TIPS

25-. Using a pointillist method on the surface creates a special vibration of light that gives movement to the work. The colored dots appear to vibrate in front of our retina.

26-. In order to create a very refined painting, it is necessary to do a sufficient amount of staining; always going from the more general to the more detailed. The details should not be defined until the last few steps.

25

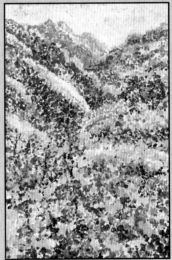

26

Painting waterfalls

o

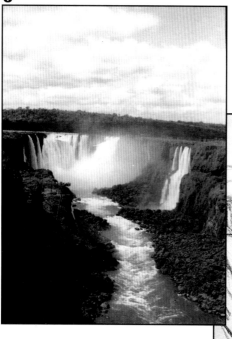

1

In the next exercise we will multiply the jet effect by depicting the millions of drops of water that fall at great velocity from waterfalls. Waterfalls are one of the most amazing phenomena that nature has given us. Carlant has been chosen to bring us through this exercise. The model is a snapshot of the Iguazú waterfalls, one of the biggest waterfalls in the world. If you are curious to know how an artist can represent such a large quantity of moving water, you should pay attention to the following instructions. You should follow them in order and practice them at home to try to reproduce this exercise done by Carlant.

Fig. 1. Start to draw in a general fashion, and try to decide on the framing and the correct proportion of the different parts of the painting. The first lines should be very concise, without any type of adornment or shadow. Charcoal is a good medium if you want to be able to make corrections easily; it is less stable than pencil, but it allows you to erase any error with a cloth, leaving hardly any mark. If you compare the drawing with the model, you will see why the artist decided to raise the horizon; to put more emphasis on the waterfalls and the riverbank.

Fig. 2. Use a brush and a watered-down brown to retrace the charcoal lines. Try to fix the profiles of the forms with paint, so that the charcoal does not dull the colors when we apply them to the surface. The artist begins his work by staining the left side of the mountain. He covers it with white and an intense green. The more shaded zones are marked by adding a point of

2

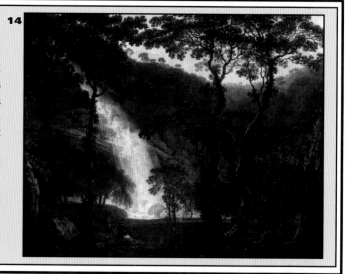

3

burnt umber to the green.

Fig. 3. Continuing on the same side of the painting, we will now paint the grass that covers the mountain with cadmium green and a little bit of ochre. The sunny zones should have warmer tones and differentiate between the greens. With permanent green, ochre and umber we will cover the cliffs to the right. Note the pointillist effect that the artist uses to hint at the texture of the rocks next to the river. The green appears to be whitened and colorless on the waterfalls in the background because of the waterfall and the vapor's distance from the vegetation. For the first wash we will use thin oil paint; it is necessary to let it dry before laying more paint on top. If you do not wait, the colors from the old marks will mix with the new, polluting all of the colors.

Fig. 4. To stress the colors of the mountains once again, continue to add small precise marks and new nuances. With a pastel green, paint the large zone that covers the

cliffs to the right. Use cobalt blue and a point of carmine to define the sky. First, we will try to cover with blue the spaces that remain between the clouds. The artist does not do this in a uniform manner, nor in a gradated manner, he uses colors that are more violet on the upper part and clearer blue on the lower part (closer to the horizon). For Carlant the function of color in these first few stages is very clear; he tries to suggest color rather than being very meticulous. Notice that there are no abrupt changes in color; the different zones of the painting blend through the borders and the smooth transitions.

Fig. 5. Continue to make the horizon line more concrete. Paint a clear violet fringe for the plain and another ochre-green one for the profile of the distant hills. Then return to the sky in

4

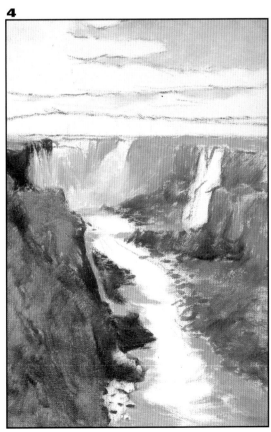

TIPS

27-. An excellent utensil for mixing oil paint colors is the spatula. It is the best meter and dosage measure that an artist can have.

28-. When you are painting with a brush it helps if the paint is more fluid for the second layer. The way to make a quantity of oil paste more fluid is to take the brush (so that it is submerged in the oil can) and mix it with oil and paste. When you brush it over the canvas, you will be able to see that the paint flows more easily.

27

28

order to smoothen the profile of the clouds; the charcoal lines can still be seen. The volume of the clouds is stressed by applying light beige onto the lower part of each cluster. By passing a flat brush over the clusters, the profiles can be blurred and become more integrated with the blue color of the sky. In the first plane, the artist spreads small stains of light green onto the riverbed. These stains were only applied to the bank, and left the central part of the paper its original white color.

Fig. 6. Now we will abandon the large brushes that we have used up until now, and with a small round brush we will start to define the forms that lie on the terrain. It is important to enrich the color of the first coat by painting the color directly on the desired spot and then increase it little by little. Darken the hills to the right again, but

MODELS

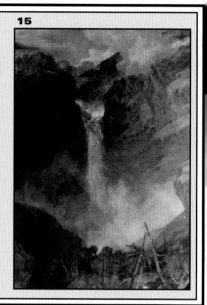

15

15-. *The large waterfall of Reichenbach* by William Turner (Cecil Higgins Art Gallery). When painting a waterfall with watercolor, you can employ various techniques. The best way to paint the water of a waterfall is by reserving the whites: you can use the liquid rubber to make reserves or you can work with a bar of wax (remember that wax repels water). One you have painted the cascade, scratch the surface of the water with the point of a cutter to simulate the form.

avoid using black in this mixture of colors: greens, reds, blues, and ochre blend together to achieve an interes-

ting richness of blackish colors. With the new additions of gray to the water, it becomes clearer which zones are co-

5

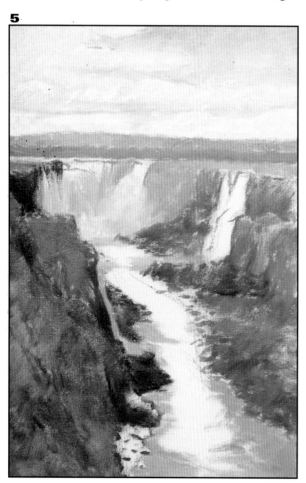

6

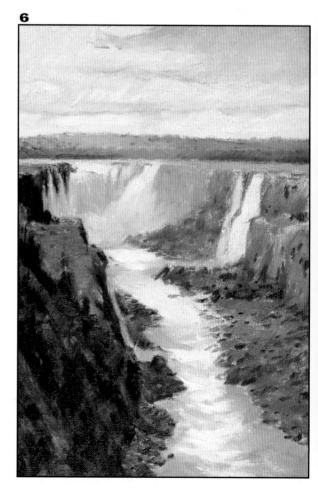

7

vered in foam and which are not. The first coats of white are applied to define the cascade. Remember that white should always be in the same direction as the falling water.

Fig. 7. Small marks of a pinkish color are applied in order to create variety and to better describe the holography of the cliffs to the right. We continue to make alterations to the riverbed and the banks that are full of rocks and vegetation. There, the tonalities are altered and small dots of color are applied to complement the effects of the fallen leaves, the agitation of the water, and the lights and shadows that are caste onto the rocks. It is important that an artist develop the capacity to maintain a clear overall vision of his work and to harmonize the large variety of tones that he uses. This means that you should restrain, from painting zone by zone, and instead, try to work on the whole work as one piece.

Fig. 8. In this last phase try not to become too occupied with details, it is impossible to try

to paint every rock or every blade of grass; it is more important to know how to distinguish between what is pictorial, that is, a problem of color and form, and what is picturesque and anecdotal. The artist finishes the first part of the water by adding grays that are bluer than the previous ones; darkening the shadowed zone to the left; and marking with slight touches of dark brown, the contrasts of the stony shore to the right. We use these last brushstrokes to compensate the unbalances that may exist among different tones and to integrate the colors of certain zones (like the development of the group of cascades in the background, we add white to the vapor cloud, the vegetation, and the water spray to the left) that could have been left out or undefined.

8

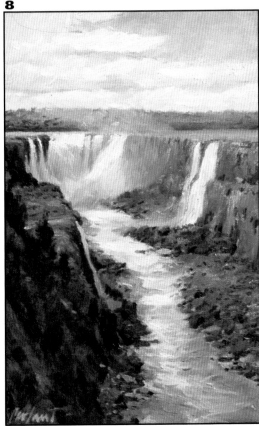

TIPS

29-. If you want to better integrate the tones; you can practice with circular movements of your fingertip.

30-. If you are trying to paint a colorful work I advise you to avoid using the color black when you need darker tones. Try to obtain black through different methods, like mixing two complementary colors; the resulting black will not completely opaque, but it will achieve the same effect.

29

30

Sunset over the ocean

In the following exercise we will develop an realistic situation in which the colors of the ocean will be converted into a range of warm colors, of bright light, and purplish reflections. Our invited artist, Óscar Sanchís decided to paint a wharf, where a few sporting and fishing boats congregate. The true protagonist of this work is the harmonic range of colors that the water presents during sunset when the sky is lit up by oranges, reds, and violet colors. The perception that we have of the surface of the water changes when it begins to reflect the lit sky with the games of reddish colors found near the horizon line. The medium the artist uses is oil and we invite you to practice this exercise in your house.

Fig. 1. In the previous drawing, not only were the basic axis of the composition traced, but also in the preliminary drawing we clearly defined all of its elements. If we want to finish the drawing of the vessels we need to begin with pictorial work

and cover the sky with a wash. Try to moisten the surface of the paper ahead of time with a small spatula, this method favors even more fusion and gradation among the colors: cadmium yellow, cadmium red, ochre, and violet (in this order going from top to bottom). Save a tiny space of the white paper to represent the sun.

Fig. 2. Finish the first phase of painting the ocean water. Given

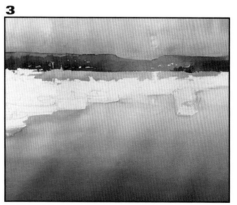

working with these large zones you have to let the paint run freely with a large brush, but at the same time you have to try to avoid the wash from forming puddles and accumulating in excess.

Fig. 3. Return to making violet by mixing cadmium red, and Ultramar blue, but this time the mix should be more saturated with paint, that is, more intense. With this color you can paint a relief of the distant sun with a uniform wash. While the paint is still wet, add the same color, but, make it more intense on the middle left to obtain the texture of the vegetation. The distant hills should have well defined profiles and be silhouetted to strongly contrast with the colors of the ocean and the sky. We can see that up to this moment, the artist preserved the white space that holds the vessels.

Fig. 4. Continue defining the group of vessels to the right with Ultramar blue, carmine, and burnt umber, and try to give the group a dominant chro-

that it is a surface that reflects the light of the sky, we can use the same mixture of colors for the water and in the same order as we did for the sky (cadmium yellow, cadmium red, ochre, and violet). Move downwards with a brush full of water from the horizon to the first plane, to form the gradate. This way we will establish a direct relation between the colors of the sky and the colors of the ocean. When

MODELS

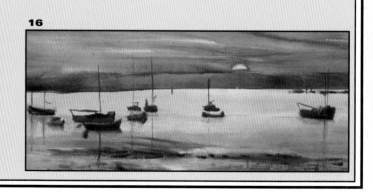

16-. *Sunset over the bay* by Ester Llaudet (artist's private collection). The dominant chromatics of a sunset tend to be the same: yellowish and reddish colors for the water and the sky, and violets to describe the undulations of the landscape and the group of vessels. The forms that the sun brings out appear in a subtle back light so that they almost always appear dark and very silhouetted. In this work you can also develop the interesting panoramic format used by the artist.

4

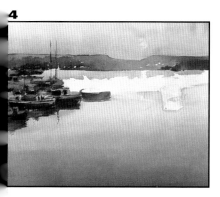

matic presided by the color violet. Try to work on defining the form of each vessel, the masts, the cabins, and the reflections that they project onto the crystal-clear surface of the water. Even though the ocean seems calm, we see how the continuous swells provoke a certain wavering undulation onto the reflections of the boats.

Fig. 5. Now we will continue with the progression of the vessels to the right. We will continue painting on the surface of the paper with a medium round brush charged with color, and then draw the forms of the vessels against the light to silhouette them- differentiating a few of the medium gradated tones. Once the form of the boats has been defined we can paint the vertical elements to give a linear counterpoint to the marks. It is important that this process be quick and decisive. Do not

define all of the vessels in the same way, work more with the ones that are on the first plane and try to silhouette these so that they appear to be behind. Little by little you will finish defining all of the vessels, interpreting them like a mass of homogenous color; this will lift them to the middle plane of the painting. Once the paper is completely covered with washes, the stridency of the white paper will be eliminated. If you encounter problems

5

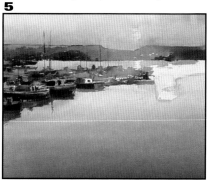

when it comes time to represent the boats in perspective, try to register the form within a rectangular form- that is within a box that has transparent faces. Fig. 6. Now, with one wash of burnt umber-violet, paint the reflections and the shadows of the vessels over the water. At first, it will seem that the colors of the boat and the colors of their

TIPS

31-. When working with *alla prima* in watercolor you have to mix the paint until you achieve a precise consistency. The diluted paint flows more easily than the dense paint.

32-. Blend together two zones of disparate colors by moistening the area and allowing the blending to occur by itself.

31

32

6

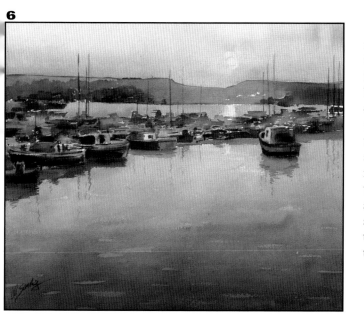

reflections are being confused, because they have similar tones. Without a doubt, if you look thoroughly, the reflections will appear grayer and one shade lighter than the boats. Stress the new brushstrokes on the first plane. To complete the effects of the water, moisten the paper and spread new brushstrokes of a semi-transparent violet on the lower part of the painting. While working over a moist surface, the new additions of color spread irregularly, forming pools and diffused concentrations of paint. The artist tries to leave small spaces without paint so that the slightly lighter previous wash remains visible. These reserves help to depict the reflections of light and contribute to the illustration of the sporadic movement of the water in the first plane.

The stormy ocean waves

In the next exercise, the texture that we give with the brushstroke is very important. The model that we are going to paint is one of the most attractive seascapes; intense swells breaking against the rocks. With a subject matter like this it is important to develop each of the different depths and colors that appear in each plane of the landscape. If you observe carefully you can see that the first plane is more detailed, and the other planes which have not been developed so concretely, appear to be more dull. Grau Carod is the artist responsible for explaining this exercise step by step. Acrylic paint will be used in this exercise. Let's see how it's done.

Fig. 1. It is very common for artists to make a pencil sketch before painting any type of model. The composition is outlined with large strokes and a few linear traces before applying the color. Smooth surfaced paper will be used which is less absorbent than watercolor paper.

Fig. 2. Once the basic form is sketched in pencil it will be

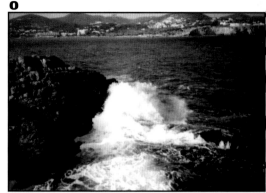

o

1

easier to begin working with color. Apply the diluted color to the drawing and use the main pencil strokes to give location and form to the elements of the landscape. First, the artist paints the colored zones that contrast most with the rocks

2

and the ocean. For the rocks, he uses brownish-gray, black, ochre, and red, and for the ocean and the distant coast, mainly blues and greens. These first brushstrokes are crude and rough; we are still trying to define the volume and spatial location of the object. The pencil marks are very obvious but we have not yet established any obvious boundaries between the different zones of the painting.

Fig. 3. In this phase we have the sketch of the painting and the presence of the main colors in the composition. Although the construction of the painting is based on remnants of color, the artist is careful with tonal relations. It is important to be aware of the different treatments of color over each of the landscape's planes. The distant plane appears more diluted be-

MODELS

17

17-. *Breakwater along the Maine coast* by John Marin (Columbus Museum of Art). It is not always necessary to use a realistic representation when trying to express the violent meeting between the water and the rocks. The artist has many resources for representing movement, and one of these is the expressionist method. Here, the waves have been represented with colors that are livelier and have more convoluted forms. The lines and colors blend to transmit the pounding of the waves. Although the rocks are treated with different colors, they repeat the same forms that are found in the ocean.

3

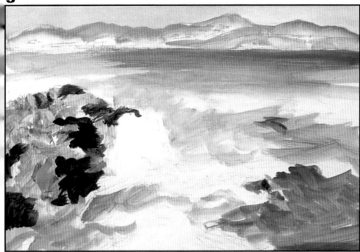

TIPS

33-. The main dark areas must be defined in order to correctly mark each part of the painting.

34-. To paint landscapes, it is re-commendable to have a good photographic archive at your disposal, well classified by the-mes. You can create this with images from magazines or your own photographs.

cause the artist has not given any texture with the brushstrokes; the closer planes have a more gestural and denser brushstroke. The brushstrokes help to establish depth in each plane. Fig. 4. Now, the artist uses a medium round pencil and adds new values to the initial phase. He paints the light part of the rocks with ochre, Siena, and orange tones. New strokes of bluish-green and grayish-green are applied onto the choppy surface of the water. These nuances of color differentiate the planes of the painting and allow the texture, volume, and luminosity of the scene to develop. He does not paint the whitish zone of the waves, for right now, they will remain

the color of the canvas. Notice that generally, the water's light areas are represented by the white of the canvas. Fig. 5. The strokes are superimposed, one on top of the other; this alternates the tonalities in the zones where the light and shade intersect. Pay attention to the quality of the strokes; they are not identical: some are short, others long, and some blend with inferior tonalities. The pencil marks are more charged each time, and the paint is more opaque and thicker. The artist starts to define the foam of the wave with white, one point of blue and one of green. Right now he does this gently, just trying to cover the strident white of the paper. The colors that are

33

4

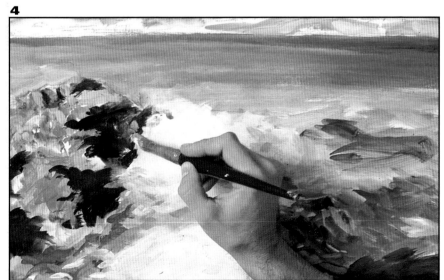

34

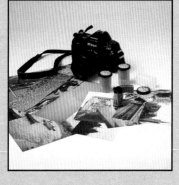

MODELS

18

18-. *The Pourville rocks at low tide* by Claude Monet (Memorial Art Gallery, University of Rochester). The ocean's colors are similar to the colors found in the sky, but the choppiness of the water presents a whitish range of colors that are inherent to the formation of the waves. The ocean has been depicted in an impressionist manner; the juxtaposition of small whitish strokes suggest the rocking of the waves against the rocks along the coast. The rocks appear dark and with little detail; we do not want them to take away from the intense swells that are without a doubt, the protagonist of this painting.

5

too bright clearly dim when placed in the distance; the strong contrast can be compensated by placing a few light gray tones on top.

Fig. 6. Now, we will leave aside the large and medium brushes and start to work with the small brush. We begin to define the profiles, the contrasts, and the forms on the first plane. We will start by adding new darker values to the texture of the rocks. By increasing the contrasts, a more volumetric effect is achieved. When we intensify the blue-green tones of the water, the profile of the wave stands out. The closer the colors are painted, the less white should be added than to previous layers, and the purer the tones should be; this will make stronger contrasts in respect to the distant planes.

Fig. 7. The painting is almost finished but the first plane is not strong enough. We continue working

with the small brush. First, we touch up the waves. With strokes of white we give more credibility to the foam. With dots we simulate splashes on the upper part of the painting. We use brushstrokes of a blue and white mixture to cover the water on the first plane and to try to simulate the foam that remains on top of the surface. These light strokes will be accompanied by other more intense strokes of indigo. Aside from creating an attractive surface with character, the way that you use the brush contributes to the definition of the elements on the first plane.

Fig. 8. With a small paintbrush the brushstrokes are continually added to the first plane of water in order to create zones with deeper color. The brushstrokes are applied with little movements so as not to take away from the background colors. In almost all

6

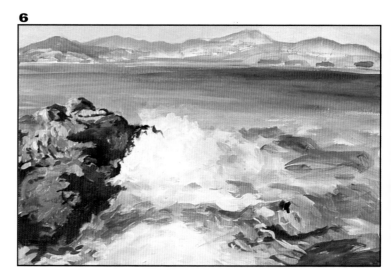

7

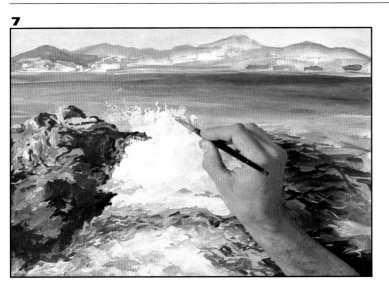

of the first plane vivacious and energetic strokes are used, integrating the water and the swells with the rocks and the coastal landscape. In this manner the ocean will present a gradation of more concrete strokes on the first plane. These will continue to melt with the background as we move into the distance of the landscape. To finish the painting, the artist intensifies the colors of the coastline that surrounds the composition.

8

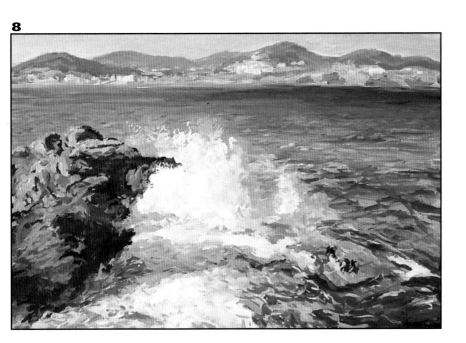

TIPS

35-. If you have decided to treat the large zones with paste, it would be useful to mix the colors carefully so that the volume of the painting will increase without altering the color.

36-. Amateur artists barely pay any attention to the brushstroke, which is not surprising, considering how difficult it can be to convincingly represent a motif.

35

36

Painting a wharf

Any scene or small detail of a landscape that calls our attention can be converted into its own painting. This is what happened with this small wharf owned by Chiang Mai in Thailand. In this model interesting whitish reflections develop when the water vibrates from the presence of the

vessels. This is one of the big themes related to the water. These provide an interesting plastic counterpoint to the ephemeral effects of the river's surface. Sofía Isus will help us to do this exercise with oil paint. The use of the brushstroke is very

important in the work of Sofía Isus. In order to reproduce this work it is important to study how the colors lie one over the other on the canvas. We invite you to practice this exercise at home and to try to understand the technique that the artist uses. Fig. 1. The motif is pretty complex, so the artist makes a preliminary sketch before applying the color. For this exercise she applies a graphite pencil over a lightly pink colored background. The outline of the drawing should be exact, so that the color and the lines can be developed more in the future. The perspective of the vessels should be taken into account Pre-

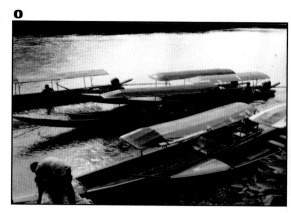

viously we talked about the necessity that many artists have to work over a colored background instead of a white one. The stridency of the white can often be detrimental to the way that the colors are perceived.

Fig. 2. Once the drawing of the model has been sketched, the main lines of the drawing need to be clarified. When using opaque paint and less delicate treatments, it is best to make the drawing with a pencil. In this exercise it is very important that the drawing remain perfectly defined before you begin to apply the color, so that the strokes mediate the zones of the vessels and the background. For paintings with a strong structural tone it is helpful to pre-paint with brownish-grays

Fig. 3. Thanks to the previous drawing of the thick lines, you can start to paint color in the zones that are now perfectly demarcated The artist

3

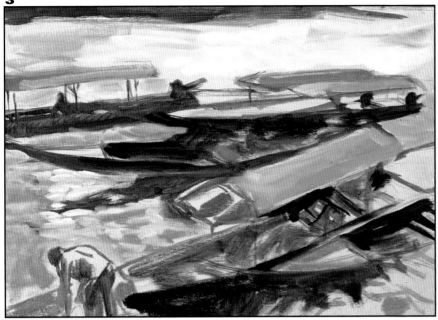

starts to make vague colored washes of fairly diluted ochre and gray. The colors that are applied are even; that is they lack gradates or some type of variation. First it is important to paint the brightest tones of the com-

4

position on the water, and then the darkest tones on the shadows of the vessels. The difference in contrast between these two zones should be the starting point of this work.

Fig. 4. The artist continues to concentrate on the initial marks of color. With ochre-yellows and oranges she paints the canopies of the vessels with dense and horizontal brushstro-

kes, and with medium-toned grays she marks the first contrasts. These seem to be full of white, but don't worry, we will rectify the colors as we advance in the painting. New brushstrokes full of white are used to describe the sparkles of light on the water's surface. The lower person on the first plane will appear darker, with clear back lighting. Then new shades of blue, red, and greens are added to the boat on the first plane- they are much more colorful than the previously applied values.

Fig. 5. Once the painting has been completely marked the small convolutions that are the color of the pink background are all that remain. The reflections of the sparkling water will be painted with unaltered titanium white by applying brushstrokes over the surface to give a definite sensation of movement to the river. With new contributions of black we define the hulls of a few vessels and with a

TIPS

37-. Drawing before painting is not essential. Some artists only make a few lines with their pencil. In any manner, if you are not that experienced and you do not know exactly how you are going to organize the painting, it is advisable that you make a preliminary drawing, especially if the motif is complicated or contains elements which are difficult to draw.

38-. In order to apply diluted paint, we need a soft brush, which is better if it is square, flat, and scarcely bristled.

37

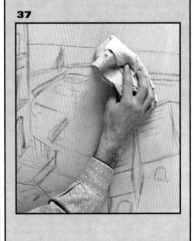

38

MODELS

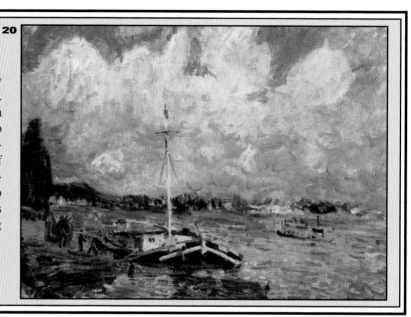

20-. *Boats on the Seine* by Alfred Sisley (Courtauld Institute Galleries, London). Many times boats suggest movement in a landscape, this is what alters the surface to create infinite distorted reflections and waves. The artist has increased the sensation of movement described in the scene with a vigorous and hard brushstroke that appears to be derived of small luminous stimuli. This type of brushstroke was very popular during impressionism.

5

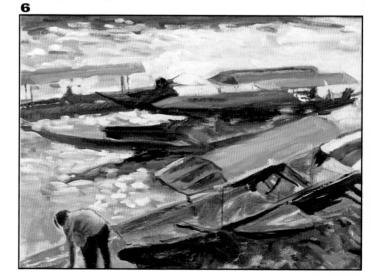

few basic brushstrokes of gray-green we define the darkest zone of water on the upper part of the work. The contrasts between the diluted paint and the concentrated paint can be made with a skillful touch using pencil lines, and paint marks.

Fig. 6. The artist applies thicker paint with a 'langue de chat brush'. This will be used to paint the bow of the central vessel a mixture of black and burnt umber, and to darken the boat situated to the upper left. This form seems almost silhouetted from the back lighting. With a fine brush and the same color the artist adds a few linear contributions to the interior of the central boat. She intensifies the shadows that the boats project onto the water. With this detail we can observe the obvious physical presence that the dense paint gives to this space. The presence of white and black in the majority of mixtures creates a large range of muddied colors.

Fig. 7. Over the previous base of color we apply more luminous and orange colors, by using ochre, cadmium red, cadmium yellow, umber, and Siena; all mixed in disparate proportions. The barge on the first plane becomes more concrete when we use a small round brush. These additions are similar to what we have practiced up until now, but be careful with the streaks of color; the denser previous layers may prevent the spatula from depositing the paint in a correct fashion. Too much paint obstructs the ability to finish some areas.

Fig. 8. The final touches are resolved by adding new strokes to the reflections of the water and paint. Add more detail to the forms of the vessels by concretely passing a fine pencil over the structure that holds up the canopy. The last coats of paint for the interior of the barges and the canopies are purer in color each time; we even add reds and

6

7

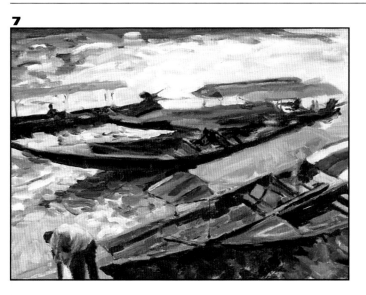

ochre that strongly contrast with the whitish colors of the water. The artist uses a dense and abundant amount of paint, which are joined with energetic and confident pencil marks to create a feeling of movement and agitation in the composition. Neither the boats nor any other element is detailed, however, the composition effectively transmits the feeling of a barge with all its color and movement.

8

The beach

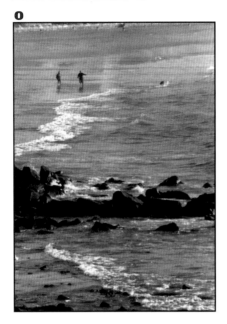

We will move on to another attractive theme: the beach. The subject matter that we are going to paint is a vertical view of a Basque beach as the tide withdraws. While the water is withdrawing you can make out the sand and a group of rocks, like the seaweed, which have the whitish reflections and formations of foam. Grau Carod will once again develop this subject matter with oil paint.

Fig. 1. The artist decides to define the first phase of the work in a quick and gestured manner. First he applies a layer of very diluted yellow-ochre to the upper-middle part in order to represent the sand. The nuances of the color were developed by using transparent layers of cobalt blue in order to maintain a translucent and moist result. With a mixture of turquoise blue and an abundance of white he starts to cover, with large brushstrokes, almost all of the work, but he reserved the upper and lower margins.

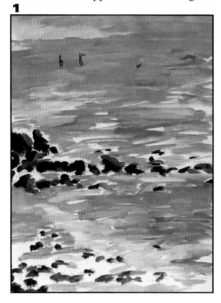

The colors remain very pastel. With nothing more than two marks, the artist was able to demarcate the two people who walked with a dog in the background of the beach. In this phase it is important that all of the brushstrokes be horizontal, so as not to ruin the effect.

Fig. 2. He increases the pictorial density of the upper part by using Ultramar blues and whites, one point of carmine for the water, and ochre and Siena for the submerged part of the rocks. The brushstrokes continue to be very loose and this contributes to the fresh and gestural feeling to the work. The brushstrokes that define the rocky forms are loose and random, which contrast with those of the ocean, which are large and stretched. The distant figures are defined a little more, although they continue to be schematic. The artist incorporates new values of purple and ochre to the ocean to create a surface, which is very interesting from a dis-

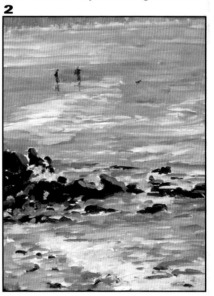

MODELS

21-. *The fishermen's shack,* by Claude Monet (Thyssen-Bornemisza Museum, Madrid). The paintings of the ample beaches in Normandy form an essential part of Monet's work. We can see how the artist varied his brushstrokes and colors to try to capture the distinct surfaces of the terrain, the shack, the ocean, the fleet of boats that are represented like simple dots, and finally, the sky. The blurred brushstrokes on the beach are used to show distance. The colors of the ocean range from white to bluish-grays on the central part of the painting, to subtle greens close to the horizon.

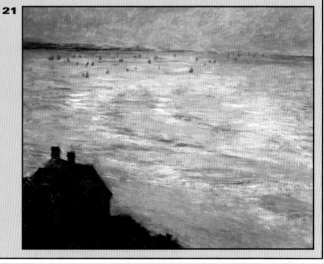

3

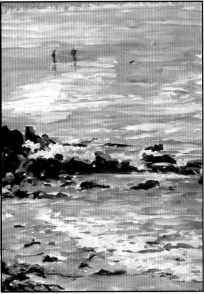

tance. A range of light ochre is used on the upper section to define the beach.

Fig. 3. Intensify the values of the central group of rocks. See how these appear to be more horizontal while the previous ones appeared more disorderly. Use a smaller brush with white paint to create the foam around the rocks and to begin to make the details more concrete. If you look at the range of blues you will see that many nuances are repeated in diffe-

5

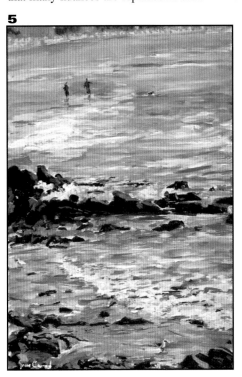

rent depths. To avoid this and to achieve a truer perspective, combine pastel bluish-greens with the blues. These blues visually acquire a tonality which may contaminate the surrounding color and change the effect. The first plane starts to become more detailed when more brushstrokes are used, while the distant planes of water appear to be straighter, smoother, and blurrier with a more dilu-

4

ted paint. In the upper part of the work a whitish wall that borders the beach is identified. Behind it the green of the vegetation peeks out.

Fig. 4. Grau Carod paints in an orderly and meticulous fashion. One thing after the other. Because of this, he advances with a slow rhythm, which gives him time to contemplate each stroke. The illuminated zones are clearly demarcated from the shadowed zones; the foam from the swell in the first plane starts to have an appropriate texture; and the rocks from the upper part of the painting have a greenish veil covering them. The vegetation from the upper part of the work already presents two values, and with this, it is already possible to identify the lines of the swell over the beach's sand.

Fig. 5. If you examine the final image with the previous one, at first glance, they may seem very similar. Do not be fooled. If you observe, thouroghly you can discover small details that were done with the small brush. The changes are not significant, but they contribute to achieve a final satisfactory image. With the last interventions of the small brush, the artist adds tones of

41

42

Siena and violet to the water that surrounds the rocks on the lower part of the painting; he adds more texture to the foam of the waves by adding white streaks; and he gives more chromatic variety to the zone where the two figures are walking. The result of these last alterations can be observed in this illustration.

A creative view of Venice

For the last exercise in this book we are going to do a much more creative exercise. We will paint a view of Venice, the city of canals, with a more impersonal and dramatic treatment. The model is a snapshot of the San Giorgio Maggiore church from an elevated point of view. Bibiana Crespo, artist and professor of art, will take us through this fresh and daring representation of a landscape that has water. The artist will use watercolor as her medium.

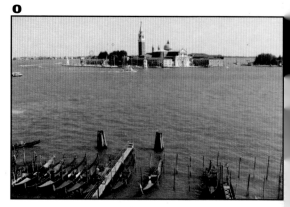

o

Fig. 1. Different to the previous works, the preliminary drawing in this work is of great importance. The artist uses a semi-hard graphite pencil (a HB for example) to demarcate the situation and form of the small island with the church and the wharf that has a group of gondo-

1

las on the first plane. Before starting to paint, make certain that the paper is tightened on the board and then start to moisten the surface of the paper. Spread the water over the entire medium and, without giving it time to dry, start to apply color. Use a clear Ultramar blue with a lot of water to dye the surface of the sky.

Fig. 2. Now we will work with the background. The artist uses absorbent paper with a color wash to apply a speckled texture to the background of color. In this phase we can see how the water becomes a richer color; it has tonalities of emerald green and ochre in the closest planes, and turquoise and Ultramar blue on the distant planes. The artist has also added a few transparent violet coats to enrich the range. Since this moment, the artist began worrying about the perspective of the color. The other elements like the gondolas and the hou-

ses in the background still remain without color.

Fig. 3. With the background defined, we can proceed to add detail to the forms. Use a small round pencil and start to draw-paint each of the vessels with bluish and violet tones. Treat the gondolas in

2

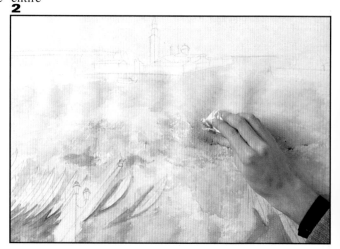

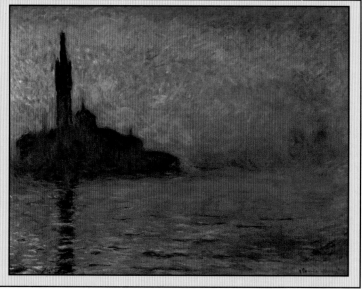

3

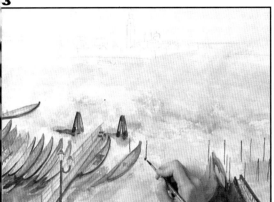

a synthetic manner with only two or three colors. The applied colors are brilliant, clean, and colorful. With the same brush use a burnt umber to paint the masts of the vessels one by one. When you paint the gondolas you have to maintain perspective; the gondolas should direct their bows towards a point situated in the middle of the church. These resources help to pronounce the effect of spatiality.

Fig. 4. Now is the time to add details to the forms by using colored pencils. Aside being nice to work with you can mix them with water to obtain a

4

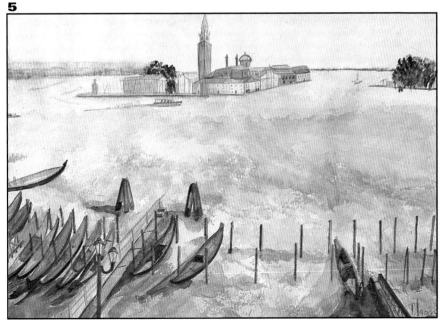

more fluid and pictorial appearance. You can cover the zones with a grayish color first with the pencil and then you can make the color more uniform by passing a pencil full of water only once over the surface. With the pencils you can add details to the small islands; you can outline the forms of the gondolas so that they stand out more against the light background; and with a simple scribble of green and Siena placed on top, you can detail the foliage of the trees.

Fig. 5. The work that remains is to increase the contrasts of the landscape and to resolve the architectural forms of the church. When we paint architecture it is best to work by planes and with uniform washes. When these have dried, we will mark the main openings with a small pencil. The sky is barely painted and the background is slightly defined. Notice how the line of the horizon has been treated with a

5

TIPS

43-. The palatine is a very useful instrument for making the first mark. When working with large brushes like this we try to avoid obsessing with details.

44-. Take into account that the water does not always completely blend the marks made with the watercolor pencils, especially if we used a little pressure against the paper, wich will create an intense line.

43

44

wash of a fading umber color. In the first plane, right where you the wharf is, the shadows of the gondolas and masts are projected over the surface of the water by using a gray-green wash.

Glossary

A

Agglutinate. Substance that is mixed with powdered pigment to make a medium of painting.

Alla prima. Direct painting technique that involves painting quickly in just one session and never going back over what one has painted.

B

Blending. Procedure that involves softening contours and areas of contact between colors to form gentle gradations.

C

Chiaroscuro. Rembrandt was a master of chiaroscuro. In his work, forms and colors are clearly visible despite being surrounded by intense shadows. In his books on painting, Parramón defines chiaroscuro as "the art of painting light over shadow".

Chromatic harmony. The balanced relationship of different colors within a painting.

Composition. The balanced and harmonized distribution of the different elements that appear in a picture. Composing involves bearing these factors in mind as one selects the best arrangements.

Covering capacity. The capacity that a color has to dominate other colors in mixtures and veils.

D

Degradation. Reducing the value of a tone, gradually making it more intense or softer, so that the transition is gradual rather than abrupt.

Dry brush. Painting technique that involves applying thick paint to the support, so that it sticks to both the pores in the canvas and the texture of the paint on the surface.

F

Film. Layer of paint or coating over the surface.

Fit. Preliminary drawing that establishes the basic structure of bodies as simple geometric forms (cubes, rectangles, prisms etc) that are often known as frames.

G

Genre. Classification of artistic techniques, such as still lives, landscapes, figures and interiors.

Graffito. Technique that involves scraping a layer of color with a sharp instrument, so that the color of the support becomes visible.

I

Induction of complementaries. A phenomenon derived from simultaneous contrasts, which complies with the norm that states that "to modify a particular color, you simply need to change the color that surrounds it".

L

Local color. The genuine color of an object when it is not affected by shadow, reflections or other factors.

M

Medium. Liquid in which pigments are held, for example linseed oil is used for oil paints and acrylic resin for acrylics. Pastel sticks can be mixed or dampened in any of these mediums.

Merging. Technique that involves spreading or reducing one or more layers of color onto to a background layer, so that the lower layer is still visible through the superimposed one.

Mixed techniques

Mixed techniques. Using different painting procedures in the same picture, or using a combination of different supports.

Modeling. Although this is a sculptural term, it can also be applied to painting and drawing to refer to the way in which different tones are applied to create an illusion of the third dimension.

O

Opacity. The capacity that a gray shade or wash has for covering a layer below it. Opacity varies from pigment to pigment.

Opaque painting technique. Pastel technique that involves applying thick layers of color to create a textured surface with little or no merging.

P

Pasting. Technique that involves applying thick layers of color to create textured surfaces.

Perspective. Way of representing the three-dimensional world on a two-dimensional surface.

Pigments. Coloring agents in powdered form that are obtained from natural sources (although some are now made synthetically) that, when mixed with an agglutinate, create paint.

Pointillism. Painting·technique that involves applying small dots to the canvas.

Pre-painting. Preliminary paint that the rest of the colors of a piece are painted over.

Preparatory sketch. The preliminary stage in the construction of a drawing or painting, from which the definitive piece can be derived. Several sketches might be made before the artist decides upon the idea he wants to work with.

Primer. Adhesive or gelatinous material that is applied to the canvas before it is painted, making the support less absorbent. It can also be used as an agglutinate in paint.

Proportion. The relationship of one part with the tonality of a piece.

S

Saturation. Value or chromatic degree of a color. Strength of a color that a surface can reflect.

Solvents. Liquids used for dissolving oil paints. The solvent for water based colors is water and for oil based products, turpentine essence, thinners and similar substances are used.

Stanley Knife. Sharp knife used for cutting paper, made up of a metal blade inside a plastic handle.

Style. In sculpture, drawing and painting, this is the way that the task is approached. It can be agitated, brusque, delicate, slow, fast... It determines the manner of working of each individual artist.

Support. Surface used for painting or drawing, such a board, sheet of paper or canvas.

T

Texture. Tactile and visual quality of the surface of a drawing or painting. It can be smooth, granulated, rough or cracked.

Tonal background. Opaque coloring in which the color is mixed with white to spread the color in a uniform way. A tonal background can also be colored.

Tonal color. Color offered by the shadow of objects.

Tone. Term that has its origins in music that, when applied to art, refers to the strength and relief of all the parts of a painting with respect to light and color.

Transparency. Way of applying color so that light or the previous layer of color filters through.

V

Value. As much in drawing as painting, volume or modeling is obtained from the tonal values of the model. At the same time, it is achieved through the comparison and tonal resolution of effects of light and shadow.

Veils. Layers of transparent color that are superimposed over the preliminary color when it is dry.

Viscosity. Measure of the characteristic fluidity of a color or medium.

Volatility. Evaporation potential of a solution.

Volatility. The capacity for a solution to evaporate.

Volume. Three-dimensional effect of a model in the two-dimensional space of a painting.

W

Wet on wet painting. Technique that involves painting over an area of recently applied paint while it is still damp. The level of dampness can be controlled, depending on the effect that the artist wishes to create.

Whiting. Ground, washed chalk that is used for priming cloth and in the composition of pastels.

Acknowledgements

The author would like to thank the following people and companies for their help in publishing this volume of the *Effects and tricks* series. Gabriel Martín Roig and Marc Calvelo for helping with the writing and the general coordination of the book; Antonio Oromí for his photography; Vicenç Piera of the Piera company for advice and orientation concerning painting and drawing materials and utensils; Manel Úbeda of the Novasis company for their help with the edition and production of the photosetting and photostatting; Óscar Sanchís et Anne Chauvin for granting us permission to use several photographs that were used as models for painting, and a special thanks to the artists Antoni Messeguer, Jean Diego Membrive, Grau Carod, Marc Calvelo, Óscar Sanchís and Eduard Lasierra.